Man Ray

Great Modern Masters

Man Ray

General Editor: Marina Vanci-Perahim

Translated from the French by Willard Wood

CAMEO/ABRAMS

HARRY N. ABRAMS, INC., PUBLISHERS

Man Ray and His Place in Twentieth-Century Art

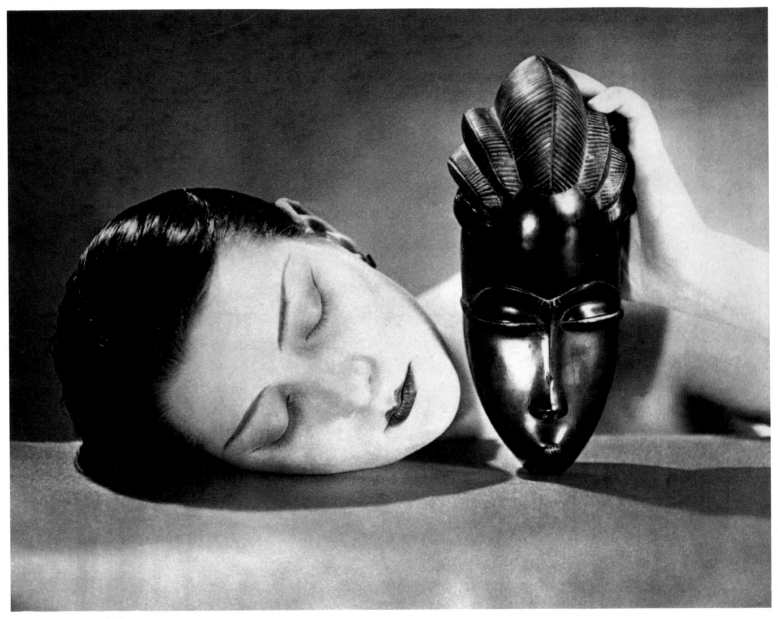

Noire et blanche, 1926.
Photograph, 9½ × 11¾" (24 × 30 cm).
Private collection, Paris

"I paint what cannot be photographed, and I photograph what I don't want to paint," said Man Ray. True to his words, he was at times a painter and at others—or even simultaneously—a photographer, but Man Ray was also a designer, an object maker, a sculptor, and a filmmaker. He wrote easily and with humor, leaving such texts as "Photography Is Not Art" and "Inventory of a Woman's Head." Yet, although he himself never ranked his various spheres of activity, he was conscious (perhaps with some regret) that his fame rested chiefly on his photographic works.

From Landscape to the Machine
Man Ray began his career as a designer and painter. His youthful work owes a great debt to contemporary French art, whose trends and cross-

currents he came to know through Alfred Stieglitz's 291 Gallery in New York. Stieglitz maintained close ties with the most innovative members of the Parisian art world and, as well as being a photographer, was an important promoter of modernism. By the early 1910s, he had held exhibitions of Paul Cézanne, Henri Matisse, and Pablo Picasso. Man Ray's portrait of Stieglitz from 1913 (plate 7) bears the clear imprint of Cubist experimentation. Most of his canvases belonging to this period, however, are landscapes inspired by the New Jersey countryside to which he had recently moved. The geometric shapes of *Ridgefield*, 1913, and of *The Village*, 1913 (plate 4), clearly betray the influence of Cézanne. The rich colors of *The River*, 1914 (plate 3), suggest the work of Matisse.

In 1914, however, the young artist painted a small rough-surfaced oil on compressed paper, entitled *Man Ray 1914* (plate 6), which shows that he had freed himself both from the constraints of representational painting and from the influence of the great masters. This highly individual work dispenses with the ballast of classical subject matter entirely—the image consists solely of the letters of the author's name and the work's date of execution.

After 1915, Man Ray's paintings were increasingly devoted to nonfigurative elements. The Revolving Doors collages of 1916–17 (plates 10–12), with their brightly colored geometric surfaces, and the oil painting *The Rope Dancer Accompanies Herself with Her Shadows*, 1916 (plate 9), were soon to be reworked using the new technology of airbrush painting. Paint is sprayed onto the support with a pistol-grip atomizer, and in the process the image loses its handcrafted quality and assumes the perfection and anonymity of an assembly-line product. Man Ray's adoption of this technique clearly reflects the ironic and provocative spirit of Dadaism. In a world where logic and the machine were all-powerful, identifying the aesthetic object with the technological was one way to place art outside the system of established values. His friendship with Marcel Duchamp, who immigrated to the United States during World War I and whose work Man Ray had known since the famous Armory Show of 1913, may have played a part in the artist's radical conversion.

Man Ray's airbrushed painting of gear wheels on glass (plate 13) is regarded by some as a nod to the mechanistic images of Francis Picabia, who had recently immigrated to the United States. Yet the work's title, *Danger/Dancer*, inscribed by the artist on the glass itself, suggests more than either allusion or wordplay. Wheels dance, just as men do. Might not the dance be dangerous or yet prove to be?

The Adventure of the Object

At the same time that Man Ray's work was moving toward abstraction, the concrete intruded into several of his paintings in the form of real objects integrated into the image.

On the subject of his *Self-Portrait*, 1916 (plate 16), Man Ray would later write: "On a background of black and aluminum paint I had attached two electric bells and a real push button. In the middle I had simply put my hand on the palette and transferred the paint imprint as a signature. Everyone who pushed the button was disappointed that the bell did not ring." Man Ray "wished the spectator to take an active part in the creation" and also wished to mock the importance of the artist's sacrosanct signature, on which the market value of the work crucially depended.

Ever since Marcel Duchamp made his *Bicycle Wheel* in 1913, the creative act could consist of simply choosing a ready-made object, which by the fact of the artist's choice was raised to the status of an artwork. In

Ridgefield (detail), 1913.
Watercolor, 16½ x 12⅝" (42 x 32 cm)

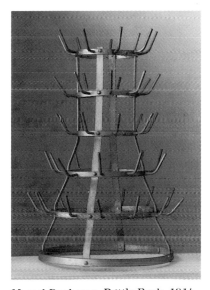

Marcel Duchamp. Bottle Rack, 1914.
Ready-made: galvanized-iron bottle dryer

Francis Picabia. "Machine Turn Quickly," 1916–17. Watercolor, 19¼ x 12⅝" (49 x 32 cm)

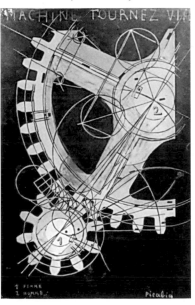

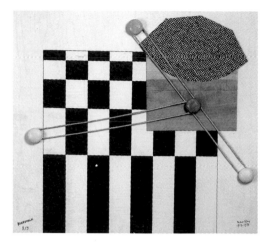

Boardwalk, *1917/1973. India ink and oil on panel, with drawer knobs and string, 25⅝ × 28¾"* (65 × 73 cm)

Still from the film Star of the Sea, *1928. Vintage print, 6⅝ × 8¼"* (16.8 × 21 cm)

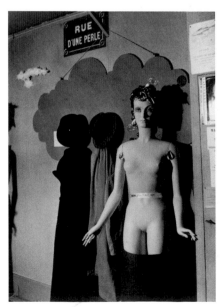

Mannequin, Man Ray, *1938. Photograph, 9 × 5⅛" (23 × 12.9 cm)*

this way, a bottle rack (see page 5) and a urinal, Duchamp's notorious *Fountain* of 1916, were to be accepted into the Western canon.

The Stamp of Surrealism

Although Man Ray was every bit as provocative in his handling of objects as Duchamp, he tended to give them a more poetic cast. The object, freed of its banality, ascended to a new level. When Man Ray wrapped a sewing machine in cloth and tied it with cord, it was transformed into a striking assemblage. The work is known as *The Enigma of Isidore Ducasse*, 1920 (plate 18), and evokes the words of the brooding Symbolist poet Le Comte de Lautréamont, pseudonymously known as Isidore-Lucien Ducasse, who described Beauty as "the chance meeting of a sewing machine and an umbrella on a dissecting table." The following year, prompted by the display in the window of a Paris hardware store, Man Ray made one of the most startling art objects ever created, *The Gift*, 1921 (plate 23), a flatiron with a row of fourteen carpet tacks glued to its bottom. Thus altered, this common household appliance was relieved of its functional aspect. Another of Man Ray's "assisted ready-mades," a metronome with the photograph of an eye affixed to its stem, was originally entitled *Object to Be Destroyed* (plate 25). Later, when the fragile object was stolen from an exhibition and afterward found in the street intact, Man Ray renamed it *Indestructible Object*.

From the time the Surrealist group formed in Paris in 1924, Man Ray took part in most of its important shows. Also a contributor to Surrealist magazines, Man Ray often collaborated with the group's poets, Robert Desnos and Paul Eluard in particular. André Breton, the group's ringleader and main theoretician, was loud in his praise of Man Ray's work.

What captured the Surrealists' imagination about Man Ray in the 1920s were his unusual rayograph images (plates 28–34), the startling and evocative effects of his solarized photographs, and the great inventiveness of his objects, followed in the 1930s by the dream imagery of his few paintings of that decade, among them *Imaginary Portrait of D.A.F. de Sade*, 1938 (plate 52) and *Le Beau Temps* (Fair Weather), 1939 (plate 54).

Of his cinematic efforts, *Star of the Sea*, 1928, is particularly Surrealist in spirit, while his earlier works, *Anemic Cinema* and *Emak Bakia*, are more abstract and experimental. Animated by a veiled eroticism, *Star of the Sea* alternates clear and blurry scenes to suggest the unbroken transition from wakefulness to sleep. But it was primarily for their pursuit of freedom, their nonconformity, and their playfulness that Man Ray was drawn to the Surrealists and came to share certain of their aims.

Practical Dreamer

"I simply try to be as free as possible. In my manner of working; in the choice of my subject. No one can dictate to me or guide me. They may criticize me afterwards, but it is too late. The work is done. I have tasted freedom. It was also hard work, but it was worth it."

In trying to sum up Man Ray's creative endeavor, perhaps the most accurate assessment would be to say that he picked his way unconcernedly across the many streams of art that sprang up in this century, never caring what reductive tag or ism was applied to his work. He jealously guarded his independence from aesthetic and ideological constraints and, thanks to his strong personality, extended the depth and range of those movements he took an interest in.

Man Ray's Universe

Man Ray's extraordinary personality is difficult to pigeonhole and seems to bring together all the traits so essential to the avant-garde artist: inventiveness, audacity, an effervescent imagination, and a continual willingness to call traditional notions of art into question. Aware of his own propensities, he once remarked, "If I had to choose between being profound or original, I'd choose originality."

The Play of Chance

Man Ray's originality was not the product of any methodical search but sprang from his inspired tinkering. His talent was for recognizing expressive forms when they arose unexpectedly in the course of his work. A broken lampshade lying on a pile of rubbish, for example, inspired him to create one of the first mobiles, *Lampshade*, 1919 (plate 24).

But photography is perhaps the realm in which chance can have the greatest effect. Accordingly, Man Ray revolutionized a technique for fixing images that has since become classic. "It was while making . . . prints that I hit on my Rayograph process, or cameraless photographs. One sheet of photo paper got into the developing tray—a sheet unexposed that had been mixed with those already exposed under the negatives—I made my several exposures first, developing them together later—and as I waited in vain a couple of minutes for an image to appear, regretting the waste of paper, I mechanically placed a small glass funnel, the graduate, and the thermometer in the tray on the wetted paper. I turned on the light; before my eyes an image began to form, not quite a simple silhouette of the objects as in a straight photograph, but distorted and refracted by the glass more or less in contact with the paper and standing out against a black background, the part directly exposed to the light." Excited by his discovery and "enjoying [himself] immensely," Man Ray repeated the operation a number of times, fixing on film images of whatever came to hand—keys, handkerchiefs, pencils, bits of string.

About 1930, when one of his negatives was mistakenly exposed to light during development, Man Ray obtained a novel effect that was both poetic and unexpected. The subjects that he photographed using this technique, mostly female nudes, appear to be surrounded by a cloud of light, or a halo. Man Ray would make extensive use of this process, for which he coined the term *solarization*, believing that it achieved the Surrealists' aim of fusing the imaginary and the real. In these images, at once fantastical, dreamlike, and erotic, Man Ray accomplishes his wish of "photographing dreams."

The Subjective Lens

Man Ray's *Self Portrait*, written at the age of seventy in an alert and off-hand style, tells of a richly eventful life. At Man Ray's side appears a procession of the most celebrated artists of the century and the most beautiful women of the period, along with a few prominent members of the aristocracy and the world of finance for good measure. The camera lens becomes sensitized in his hands to the point where it registers more than immediate reality. "The portrait of a loved one," wrote André Breton, "should not only be an image that makes you smile but an oracle you can consult." Such are Man Ray's photographs of Duchamp, Tristan Tzara, Antonin Artaud (plate 39), Max Ernst (plate 42), Breton (plate 41)—all friends of his—and the photographs of the women who were his muses: Meret Oppenheim (plate 43), Dora Maar (plate 44), Alice Prin (Kiki of Montparnasse), Lee Miller, and Juliet Browner, his wife. Although documents of an age, these portraits are above all masterpieces of the photographic art.

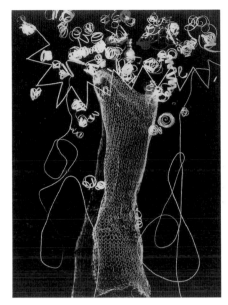

Rayograph, *1926. 15⅝ × 11⅝"* *(39.7 × 29.5 cm)*

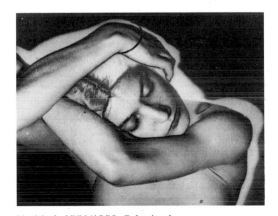

Untitled, *1931/1980. Solarized photograph, 9½ × 12" (24 × 30.5 cm)*

Marcel Duchamp, *1919. Black-and-white photograph, 16 × 11⅞" (40.5 × 30.3 cm)*

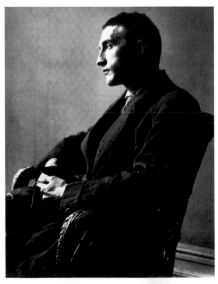

Biographical Outline

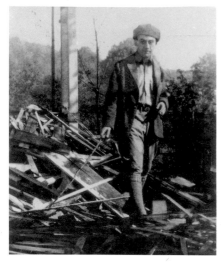

Self-Portrait, *Ridgefield, 1919*

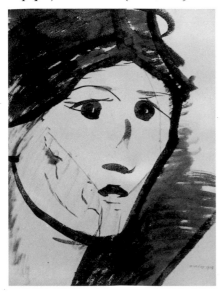

Portrait of Adon Lacroix, *1914. Gouache on paper, 25⅝ × 18⅞" (65 × 48 cm)*

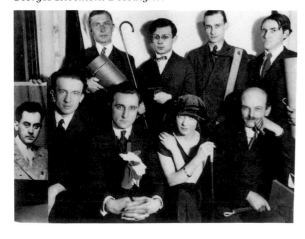

The Dadaist Group, *Paris, 1922. From left to right, standing: Paul Chadourne, Tristan Tzara, Philippe Soupault, Serge Charchoune; in photograph: Man Ray; seated: Paul Eluard, Jacques Rigaut, Mick Soupault, Georges Ribemont-Dessaignes*

1890 Emmanuel Radnitsky, later Man Ray, born in Philadelphia, Pennsylvania, on August 27, the son of Melach and Manya Radnitsky, both recent Russian Jewish immigrants.

1897 Family moves to Brooklyn, New York. On his seventh birthday, receives a box of crayons and begins to spend all his spare time drawing, then painting.

1904–9 In high school, Man Ray is noted for his interest in freehand and mechanical drawing. On graduation his teachers recommend him for a scholarship in architecture, but he declines and takes a series of odd jobs: apprentice at an engraving studio, draftsman in an advertising agency, illustrator for a publisher of technical works on mechanical construction.

1910–12 Takes life drawing classes at the Ferrer Modern School in uptown Manhattan. Attends the theater and opera. Becomes a regular visitor at the 291 Gallery, where Alfred Stieglitz champions and exhibits the modernists of the Paris School.

1913 With the poet Alfred Kreymborg, rents a shack in Ridgefield, New Jersey, where he joins an informal colony of avant-garde artists. There, he meets the Belgian poet Adon Lacroix, the pen name of Donna Lecoeur, who becomes his wife in 1914. She introduces him to modern French poetry: Charles Baudelaire, Arthur Rimbaud, Le Comte de Lautréamont, Guillaume Apollinaire. Paints colorful Cubist-inspired landscapes and figures. Visits the Armory Show of European modernists in New York.

1914 Postpones his plans for a trip to France because of the outbreak of World War I. Paints *Man Ray 1914*.

1915 Self-publishes *A Book of Divers Writings* [sic], consisting of poems by Adon Lacroix with calligraphy and original lithographs by Man Ray. Prints *The Ridgefield Gazook*, a four-page pamphlet with pen-and-ink drawings. Meets Marcel Duchamp. First one-man exhibition in New York of Man Ray's paintings and drawings.

1916–17 Attends gatherings organized by the poet and modern art collector Walter Arensberg along with Duchamp, Francis Picabia, Jean Crotti, and Edgar Varèse. Founds the Society of Independent Artists with Duchamp and Arensberg. In collaboration with Duchamp and Picabia, publishes *Rongwrong*, a Dadaist journal. Produces his Revolving Doors series.

1919 Appearance of the first and only issue of the French-English magazine *TNT*.

1920 Devotes more and more time to photography, which he had taken up a few years earlier for the sole purpose of making reproductions of his own work. Along with Duchamp, he experiments with photography (stereophotography in particular) and with film. Meets Katherine Dreier and joins her and Duchamp in founding the Société Anonyme, "a public, noncommercial center for the study and promotion of modern art."

1921 Publishes, with Duchamp, the art journal *New York Dada*, which folds after one issue. Enters into correspondence with Tristan Tzara. Duchamp returns to France. Man Ray moves to Paris, where he is welcomed by the Dadaists. A number of its leading members, including Breton, Louis Aragon, Max Ernst, Paul Eluard, and Tzara, contribute to the catalogue of his first exhibition in Paris at Philippe Soupault's bookstore, Librairie Six. Invents the rayograph. Meets Jean Cocteau. Moves to the bohemian district of Montparnasse. Meets Kiki (Alice Prin), who becomes his lover and model.

1922 In a period of intense activity, photographs artists and takes fashion pictures for the designer Paul Poiret. Publishes a collection of his rayographs entitled *Les Champs délicieux* (Delicious Fields), with a preface by Tzara.

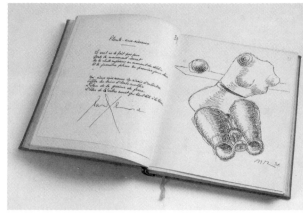

Jumelle (Twin), *1936.*
Drawing from Les mains libres, *1937*

1923 Releases his first movie, *Return to Reason.*

1924 First monograph on Man Ray, by Georges Ribemont-Dessaignes. Contributes to the Surrealist magazine *La Révolution surréaliste.*

1925 Participates in the first Surrealist exhibition, at the Galerie Pierre in Paris. Takes fashion photographs for *Vogue.*

1926 The Galerie Surréaliste opens with an exhibition of Man Ray's work. Premiere of the film *Emak Bakia.*

1928 Premiere of the film *Star of the Sea,* based on a poem by Robert Desnos.

1929 Shoots *Mysteries of the Château of Dice* at the Vicomte de Noailles's château in the south of France.

1930–31 Creates first solarized prints. Collaborates on the magazine *Le Surréalisme au service de la Révolution.*

1936 Contributes works to the "Surrealist Objects" exhibition at the Galerie Charles Ratton in Paris, the International Surrealist Exhibition in London, and "Fantastic Art, Dada, Surrealism" at the Museum of Modern Art in New York.

1937 Publication of *Les Mains libres* (Free Hands), with poems by Eluard and thirty-six drawings by Man Ray. Also publishes *Photography Is Not Art*, a portfolio of twelve photographs with an introduction by André Breton.

1938 Participates in the International Surrealist Exhibition in Paris as its "master of lights" and contributes a store mannequin to the *Rue d'une Perle.* One-man shows in Paris and London.

1940 Paris occupied by the Germans. Man Ray moves to Hollywood.

1946 Marries Juliet Browner in Beverly Hills at a double wedding with Max Ernst and Dorothea Tanning. Participates in the Whitney Museum's "Pioneers of Modern Art in America" exhibition in New York.

1948 Publishes an album of drawings entitled *Alphabet for Adults.* Paints his Shakespearean Equations series.

1951 Returns to Paris, taking a studio on the Rue Férou.

1953–60 Series of one-man exhibitions in Los Angeles, Paris, and New York. Participates in several prestigious exhibitions honoring Dadaist and Surrealist art: the Dada Expositions in Amsterdam and Düsseldorf, and the Exposition inteRnatiOnale du Surréalisme (EROS) in Paris.

1961 Awarded the gold medal in photography at the Venice Biennale.

1963 Publication of his autobiography, *Self Portrait,* in London.

1966 First major retrospective of Man Ray in America, at the Los Angeles County Museum of Art.

1971–72 A series of retrospective exhibitions in Milan, Rotterdam, Denmark, and the Musée National d'Art Moderne in Paris.

1973–75 The New York Cultural Center organizes an exhibition in honor of his eightieth birthday entitled "Man Ray, Inventor, Painter, Poet."

1976 Man Ray enters 160 photographs in the Venice Biennale. Death in Paris on November 18.

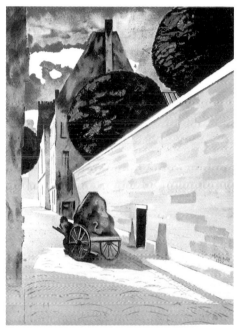

Rue Férou, Paris, *1952.*
Color lithograph, 26 × 19⅞" (66 × 50.6 cm)

Man Ray in his studio, 1960

Life Studies

In his *Self Portrait*, Man Ray looked back on his apprentice years thus: "I had gloated over reproductions of Greek statues and Ingres's nudes, had made drawings of them ostensibly as exercises in art. . . . Now, with my evenings free, it occurred to me that it might be a good idea to join a life-class."

After trying a number of drawing classes and being disappointed by their rigid academicism, Man Ray decided to attend an evening course at the Ferrer Modern School. The much freer spirit that reigned there can be seen in the charcoal and pen-and-ink drawings that Man Ray executed around 1912, which are notable for their free and limber line. In *Nude*, 1912 (plate 1), the artist captures the model's pose in firm and assured strokes.

The same undeniable mastery of drawing is evident in other of his youthful works—both in such portraits as *Self-Portrait*, 1914 (plate 2), and *Adon Lacroix*, 1914 (see page 8), and such landscapes as *Ridgefield*, 1913 (see page 5). But more than any school or teacher, what contributed to Man Ray's development as an artist was his direct contact with European modernism. Looking at his early figurative work, one can see Cézanne's geometric forms in *The Village*, 1913 (plate 4), the coloration of the Fauves in *The River*, 1914 (plate 3), and the analytical vocabulary of Cubism in *Portrait of Alfred Stieglitz*, 1913 (plate 7).

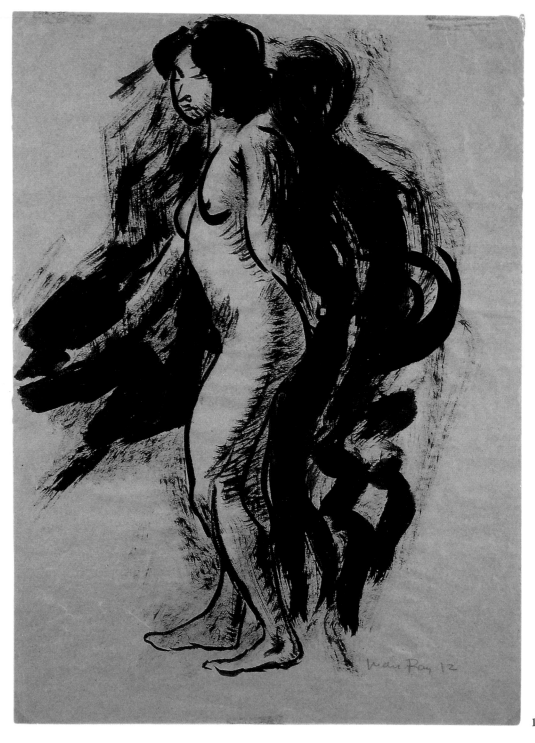

1 Nude, *1912*

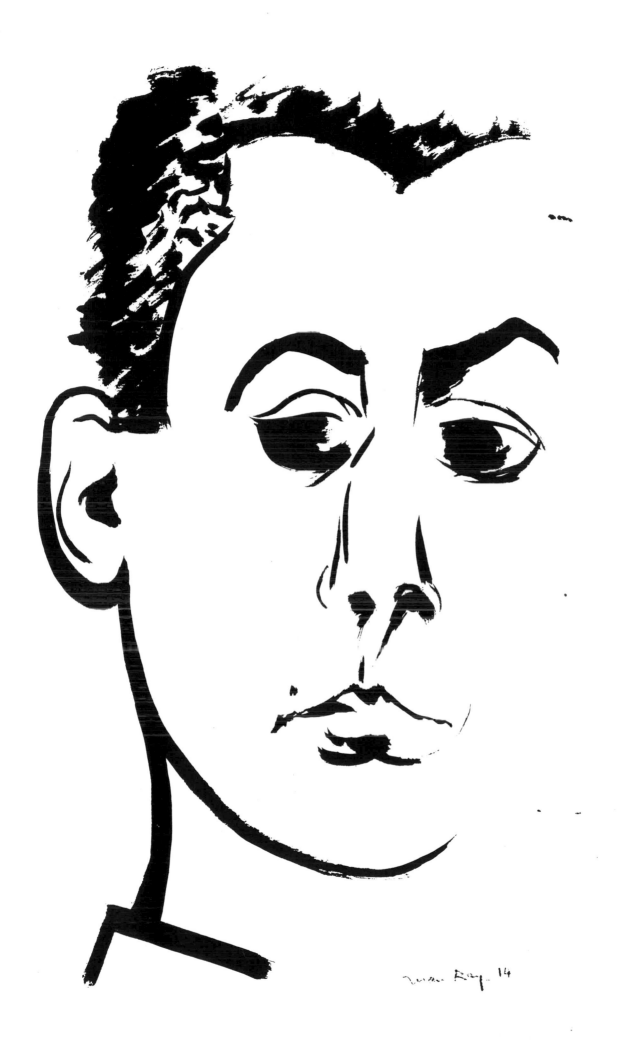

2 Self-Portrait, *1914*

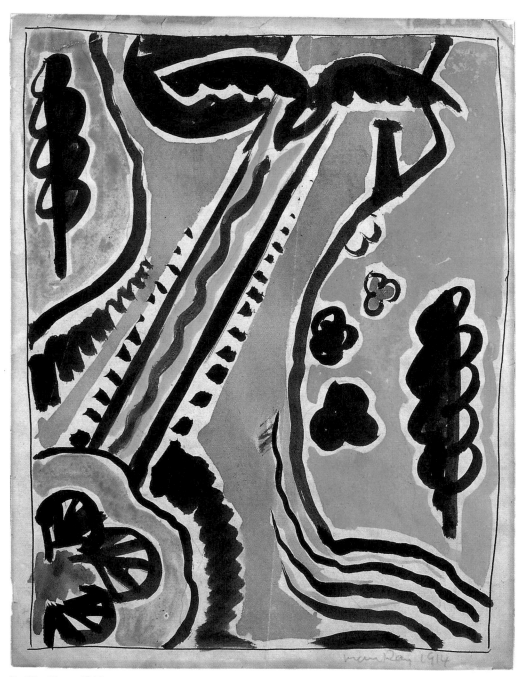

3 The River, *1914*

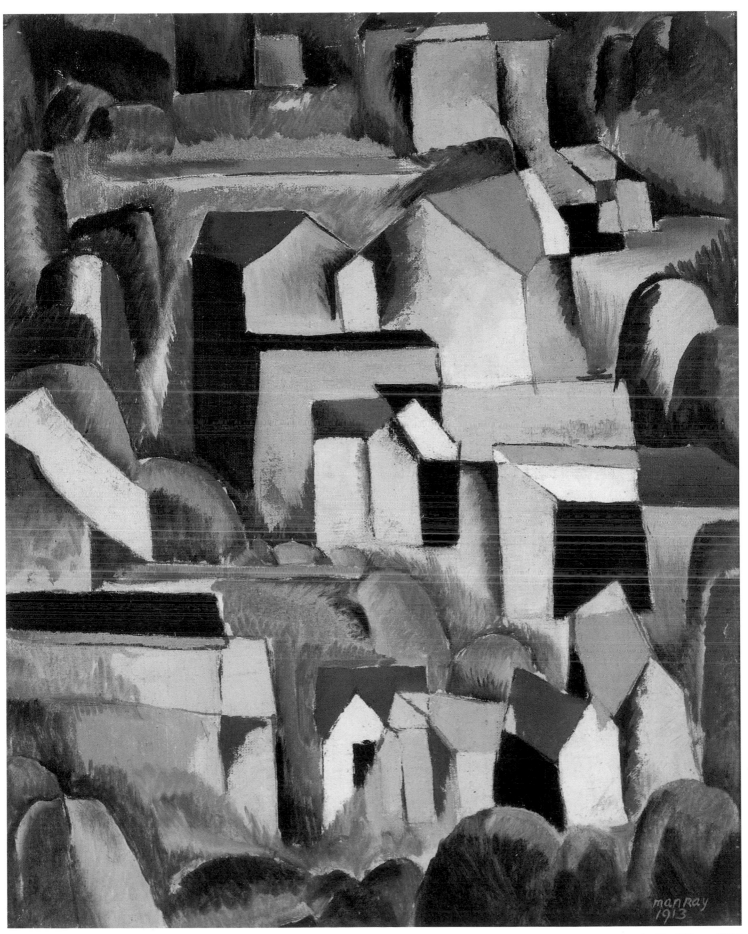

4 The Village, *1913*

5 The Lovers, *1914*

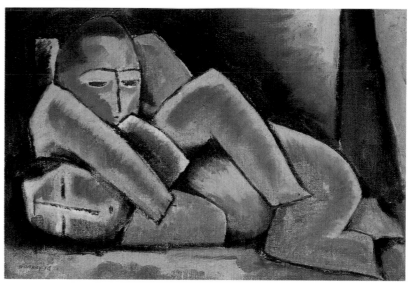

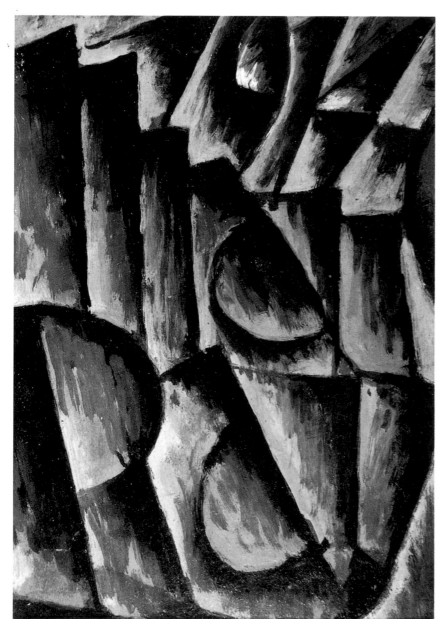

6 Man Ray 1914, *1914*

In 1914, not long after completing a large canvas composed of "elementary human forms in alternating blue and red, and gray horses also simplified," today known as A.D. MCMXIV *and considered a premonition of the coming war, Man Ray decided he would no longer paint from nature. This oil from the same year, whose only motifs are a date, 1914, and a name,* Man Ray, *is evidence of the immediate implementation of this resolve.*

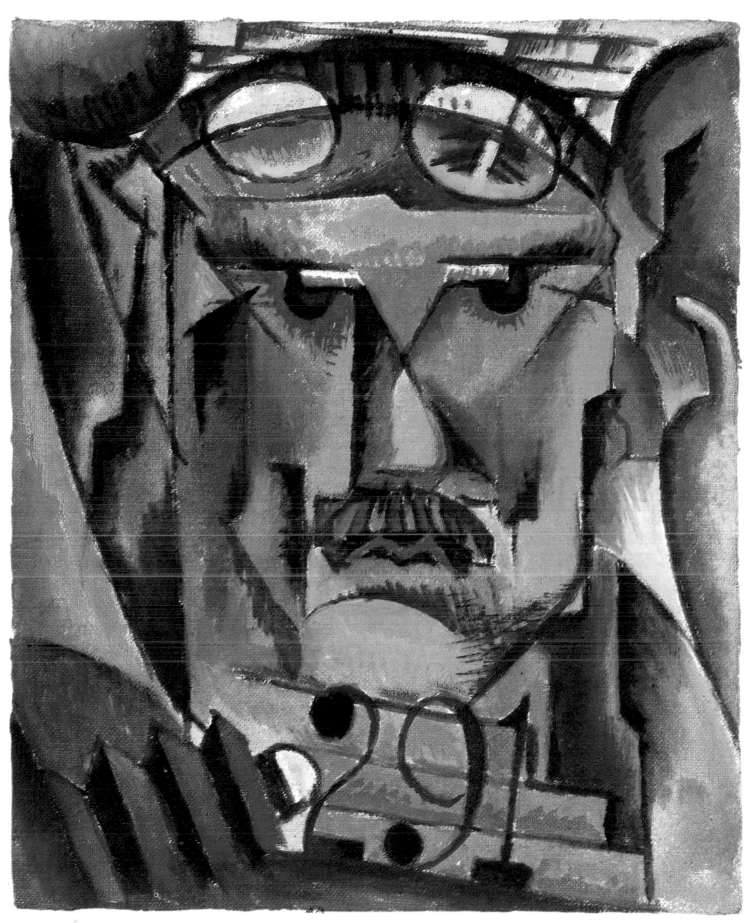

7 Portrait of Alfred Stieglitz, *1913*

The Mechanistic Model

"I had decided that sitting in front of the subject might be a hindrance to really creative work. . . . Not only would I cease to look for inspiration in nature; I would turn more and more to man-made sources."

In the early 1910s, artists as different as Fernand Léger, Robert Delaunay, Constantin Brancusi, Duchamp, Picabia, and the Italian and Russian Futurists expressed their strong interest in the landscape of the modern world, peopled as it was with many kinds of machines, some fascinating, others to be looked at with distrust or irony. With his interlocking geometric forms, his large areas of flat, bright colors (plates 9, 10–12), and his drawings that read almost as engineering blueprints (plates 13, 15), Man Ray successfully evokes the mechanistic universe, the universe derived from "man-made sources."

The change in Man Ray's artistic vision becomes apparent in his work starting in 1915. Recently returned to metropolitan New York, the artist felt the influence of the city's rapid rhythms and industrial aspect.

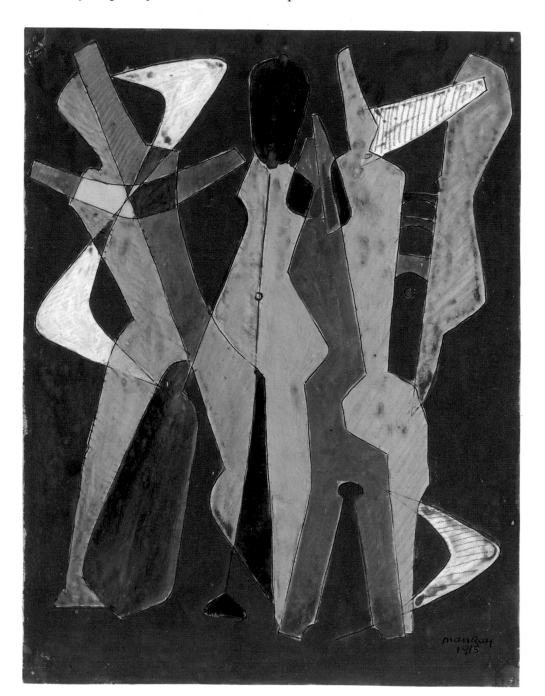

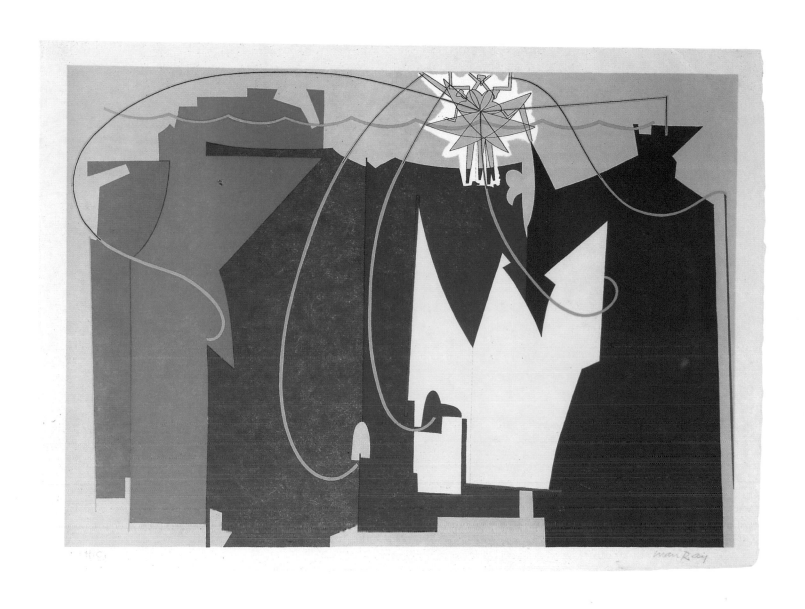

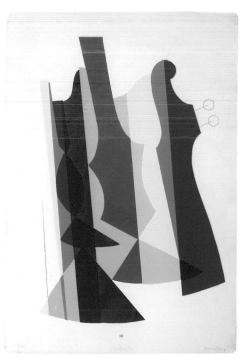

10 Orchestra, *1916–17/1926*

11 Mime, *1916–17/1942*

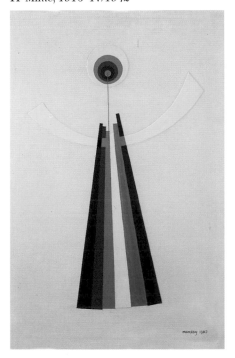

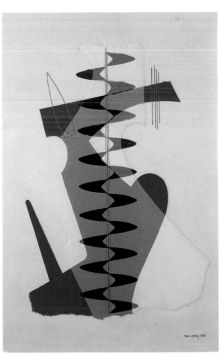

12 The Meeting, *1916–17/1942*

13 Danger/Dancer, *1920*

The subject of this work is none other than the geared wheels used in machinery to transmit motion. The title is inscribed on the image in such a way that it can read either as "Danger" or "Dancer," contributing to the ironic and ambiguous effect of the work.

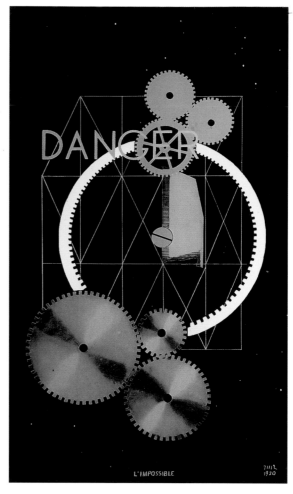

L'IMPOSSIBLE

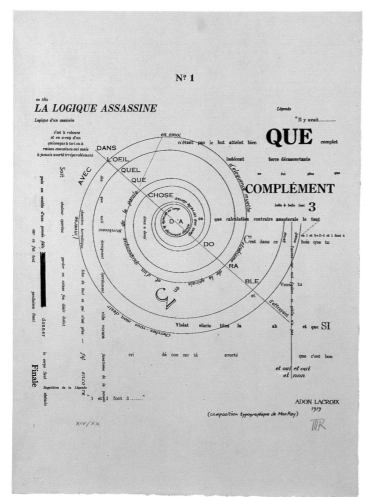

14 La Logique Assassine, *1919*

Close in spirit to the "calligrams" created by the French poet Guillaume Apollinaire (in which the poet turns visual artist and makes a collage of the typographic elements of his poem), works of this kind were among the most prized in the proto-Dada and Dada magazines published in New York from 1915 to 1919: 291, TNT and New York Dada. Man Ray created this typographic design for a poem by his wife Adon Lacroix.

Opposite:
15 Boxing Match, after Marcel Duchamp, *1920*

18

Pied du jongleur de centres de gravité

Vêtement de la mariée

2ᵐᵉ Bélier

1ᵉʳ Bélier

(les 3 pts. A, B, C, sont dans un même plan vertical;)

T'

R'

T'

R

X'

X'

G

3ᵐᵉ Sommet

D'

2ᵐᵉ Sommet

Retour de la bille de Combat en A

D

1ᵉʳ Sommet

C

B

A

EA VI/XII

Man Ray

"Objects of My Affection"

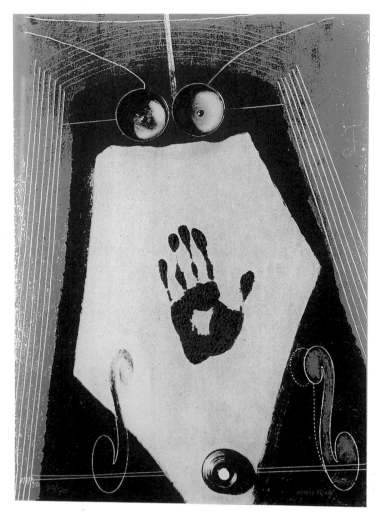

16 Self-Portrait, *1916*

Opposite:
17 Coat Stand, *1920*

When, toward the end of his life, Man Ray assembled those objects for which he felt a special attachment from the many he had created in the course of his career, this was the title he gave them. Stripped of their utilitarian function, some objects acquired an aggressive edge, such as *The Gift* (plate 23) and *Object to Be Destroyed* (plate 25); others were mysterious, such as *The Enigma of Isidore Ducasse* (plate 18), or evocative, such as *Obstruction* (plates 19, 20). All, however, reveal a poetic sense of humor, a trademark that would continue in evidence into the 1960s when Man Ray made *Close-up* (plate 27) and *Serious Man* (plate 26), at a time when Pop art was in full swing. It was not by accident that Andy Warhol, recognizing Man Ray as a precursor, devoted a series of paintings and silkscreens to him.

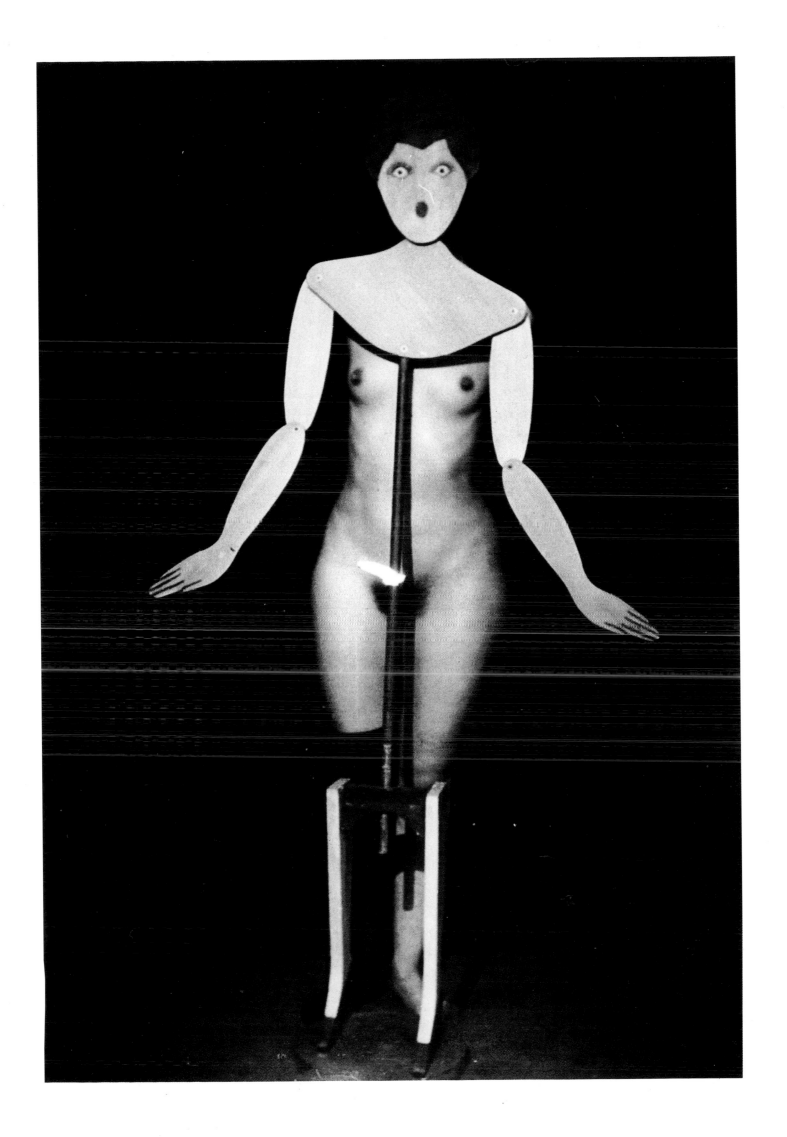

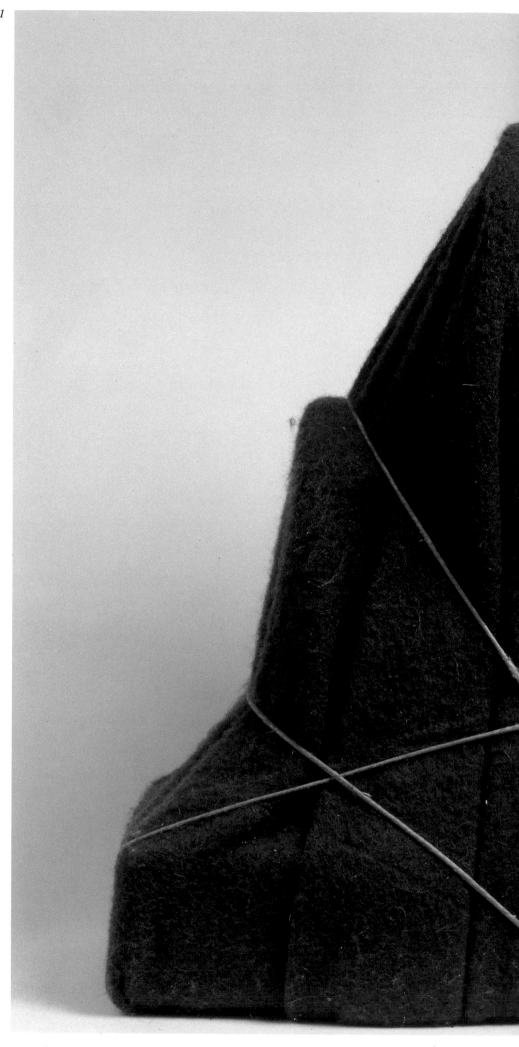

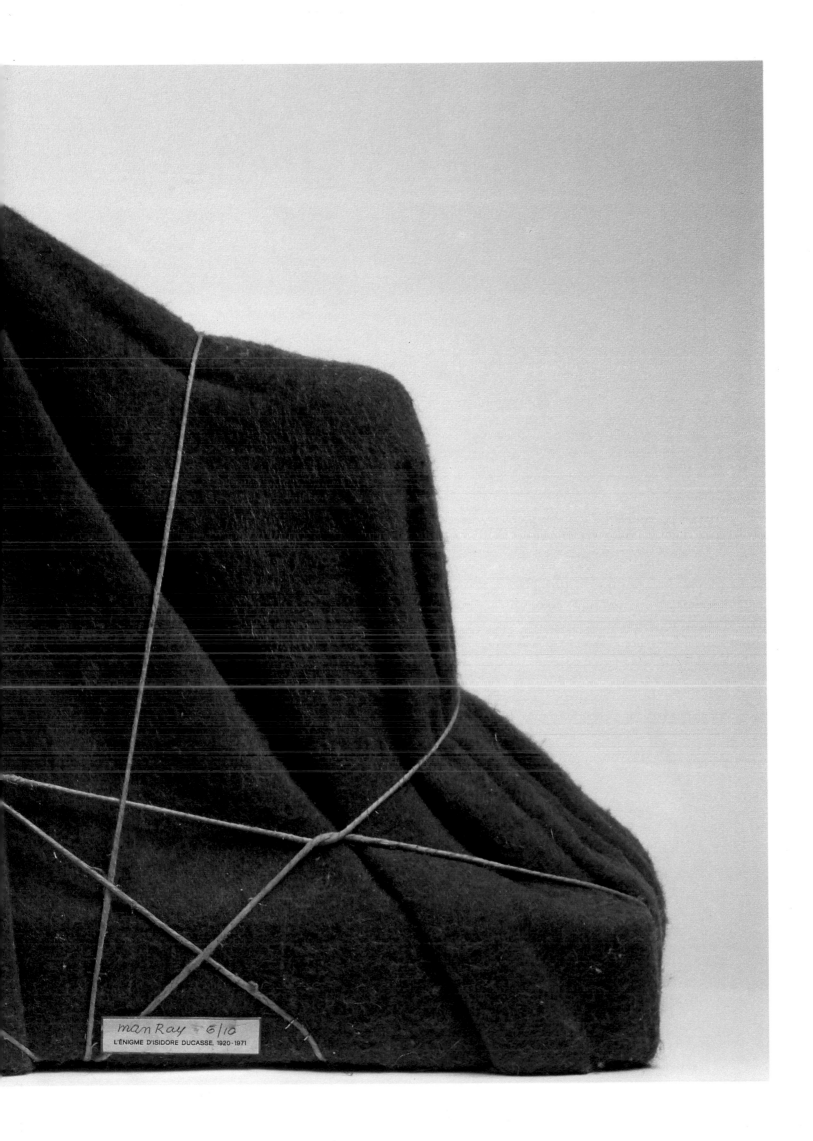

man Ray 6/10
L'ÉNIGME D'ISIDORE DUCASSE, 1920-1971

23

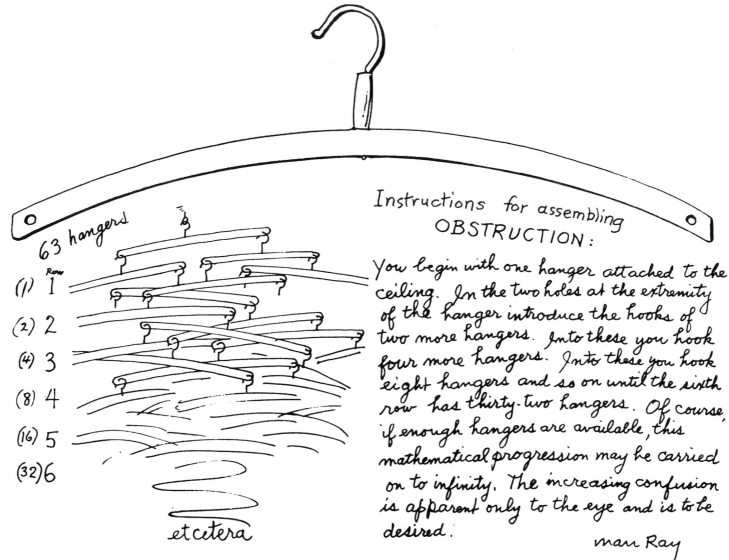

63 hangers

	Row
(1)	1
(2)	2
(4)	3
(8)	4
(16)	5
(32)	6

etcetera

Instructions for assembling
OBSTRUCTION:

You begin with one hanger attached to the ceiling. In the two holes at the extremity of the hanger introduce the hooks of two more hangers. Into these you hook four more hangers. Into these you hook eight hangers and so on until the sixth row has thirty-two hangers. Of course, if enough hangers are available, this mathematical progression may be carried on to infinity. The increasing confusion is apparent only to the eye and is to be desired.

man Ray

19 Obstruction: Assembly Instructions, *1920/1964*

20 Obstruction, *1920/1964*

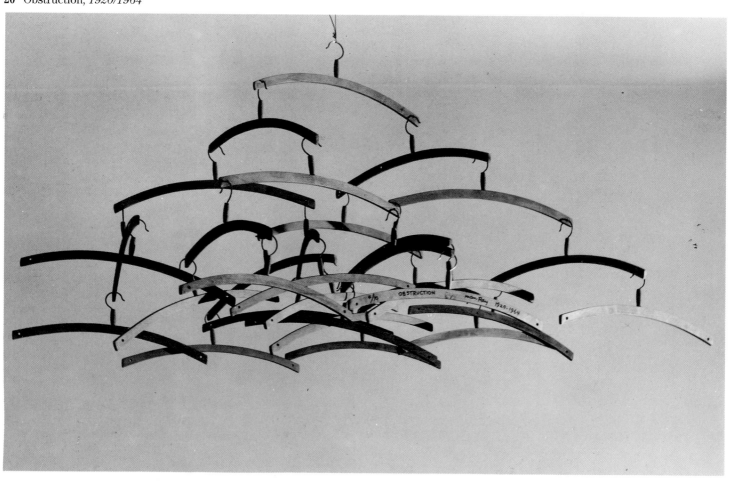

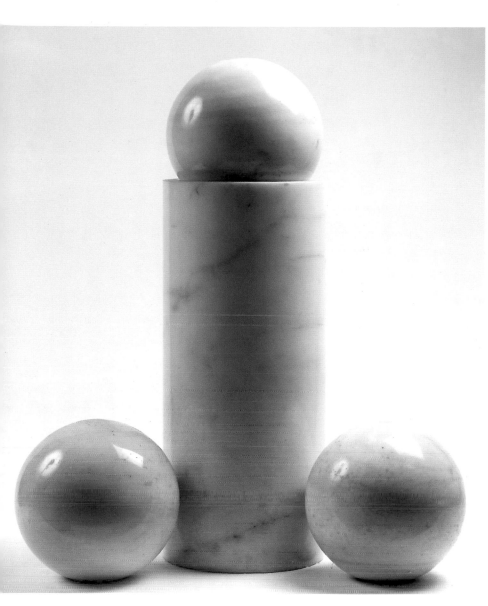

21 Priapus Paperweight, *1920/1972*

22 New York, *1920/1973*

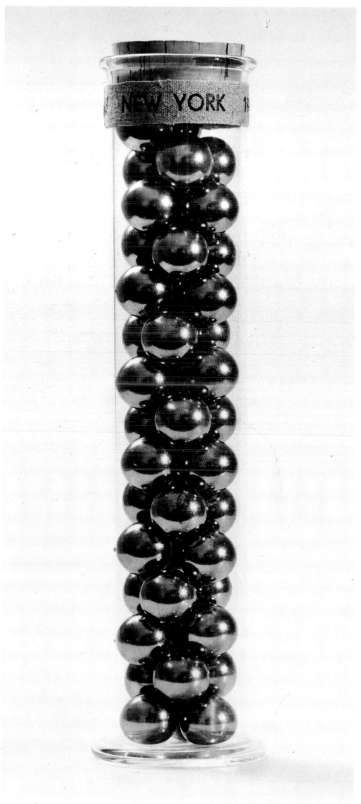

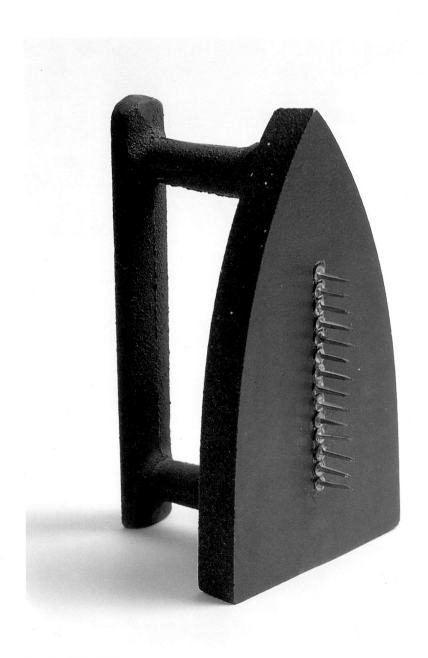

23 The Gift, *1921*

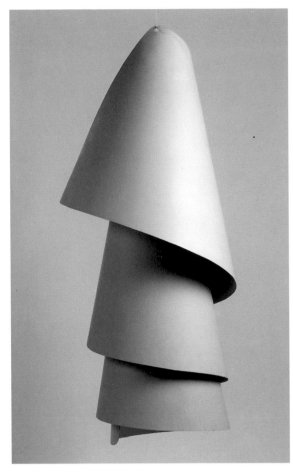

24 Lampshade, *1919/1964*

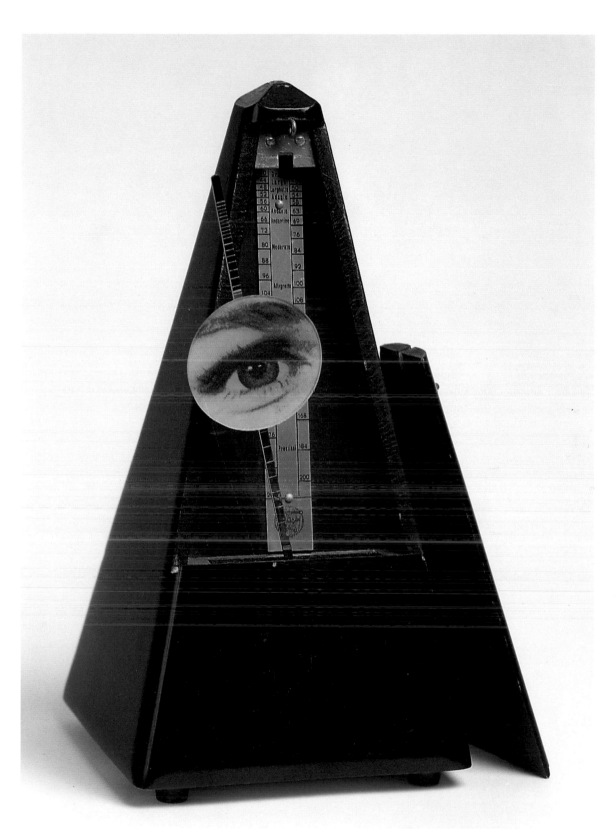

25 Object to Be Destroyed, *1923/1963*

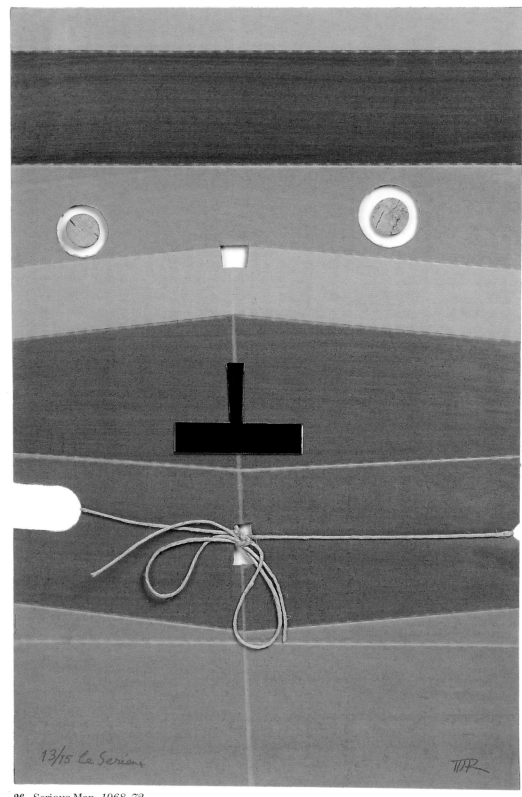

13/15 Le Serieux

26 Serious Man, *1968–72*

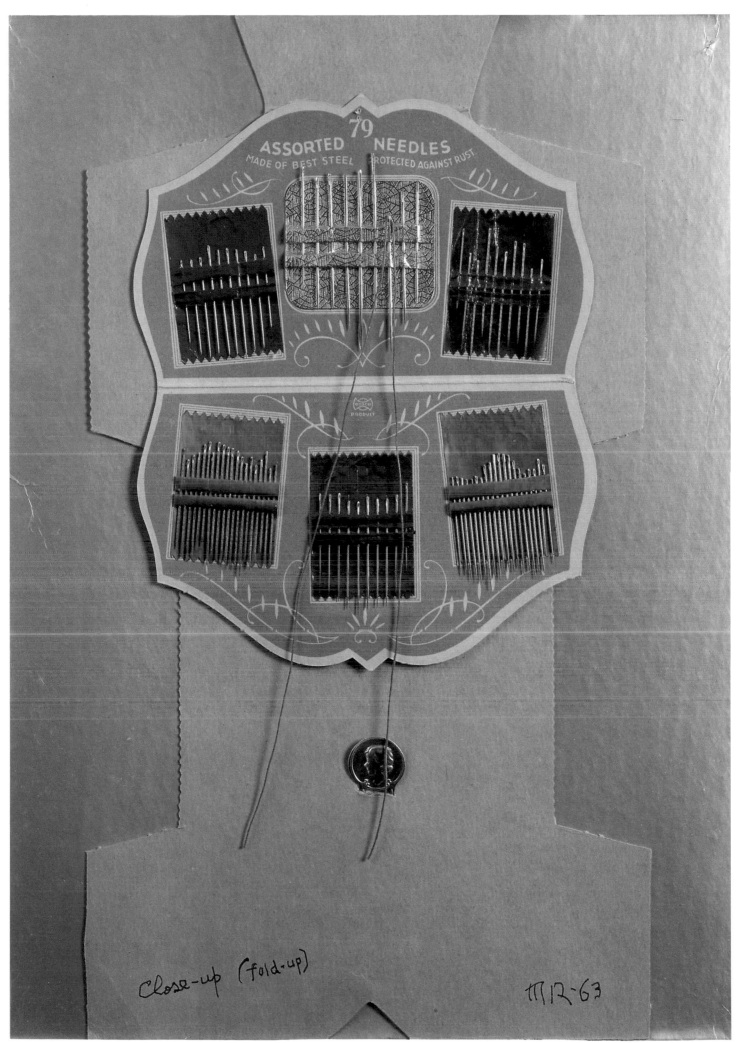

Close-up (fold-up)

MR-63

27 Close-up, *1963*

The Rayographs' "Delicious Fields"

It was pure chance, almost, that led Man Ray to produce his first camera-less photographs. A German Dadaist, Christian Schad, however, had experimented with the same technique a few years before and produced

28 Delicious Fields, *1921–22*

images of flat objects laid directly on photographic paper. The poet Tristan Tzara, to whom the so-called Schadographs were already familiar, was excited to discover the more virtuosic rayographs. Combining motion and translucency, Man Ray gave his objects a ghostly three-dimensionality that was both evocative and unusual. It was at Tzara's proposal that Man Ray assembled a few of these photographs and published them in a limited edition in 1922 under the title *Les Champs délicieux* (Delicious Fields), with a preface by his poet friend (plates 28–31).

29 Delicious Fields, *1921–22*

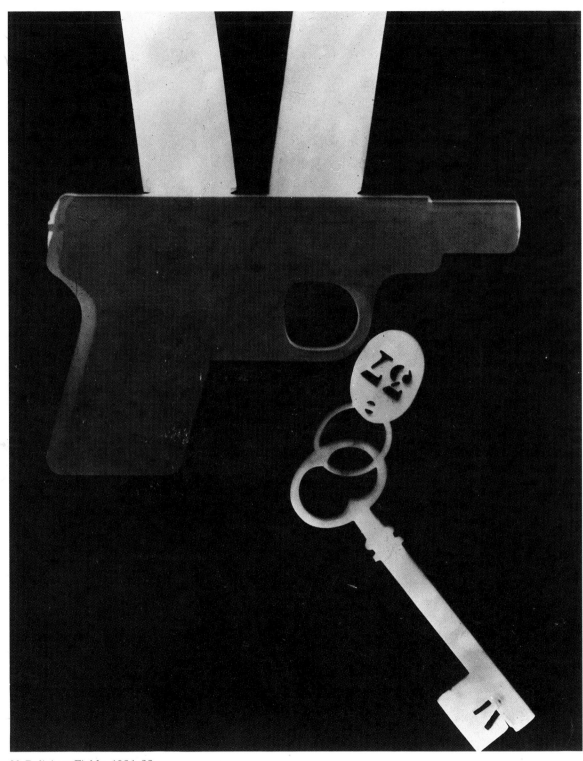

30 Delicious Fields, *1921–22*

*The negative image of highly familiar
objects reveals a strange and ghostly reality,
arising from the play of chance effects.*

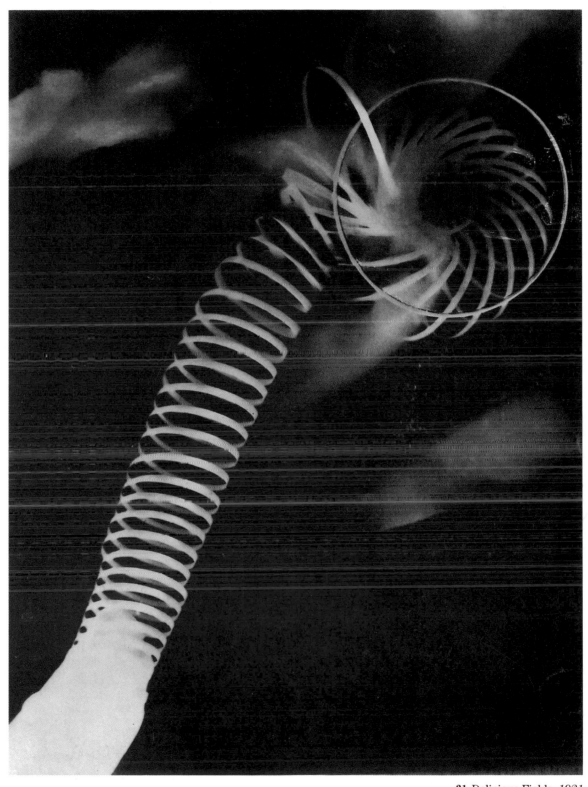

31 Delicious Fields, *1921*

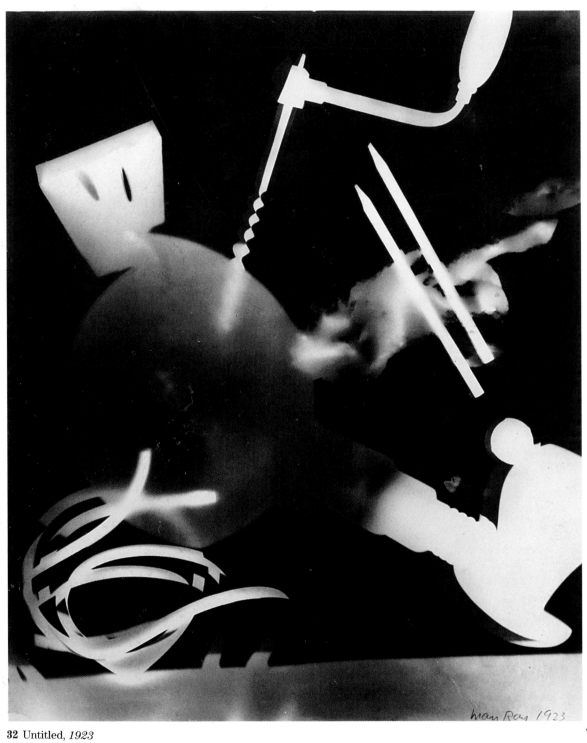

32 Untitled, *1923*

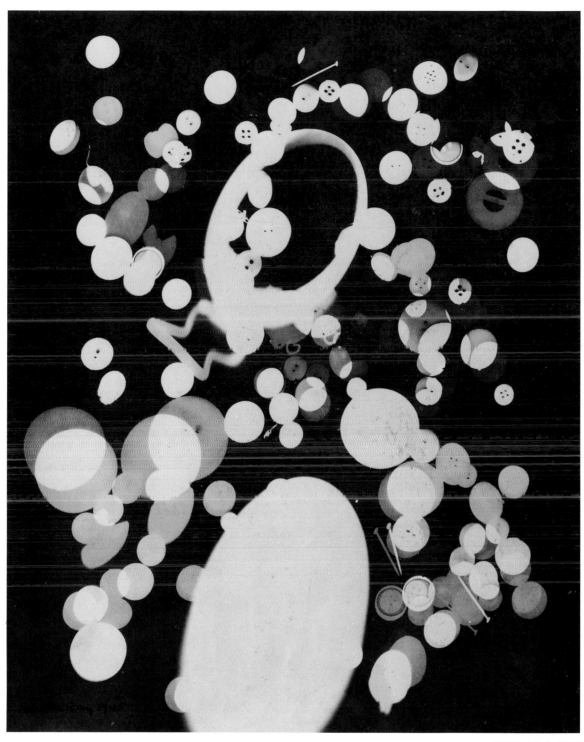

33 Untitled, *1945*

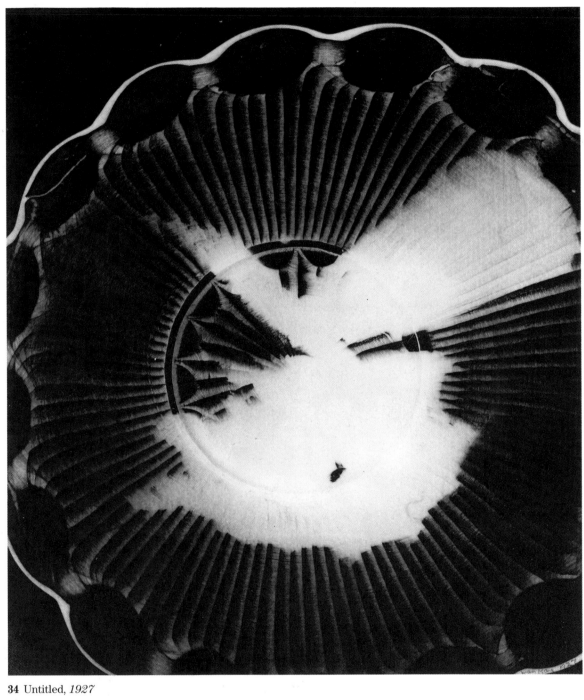

34 Untitled, *1927*

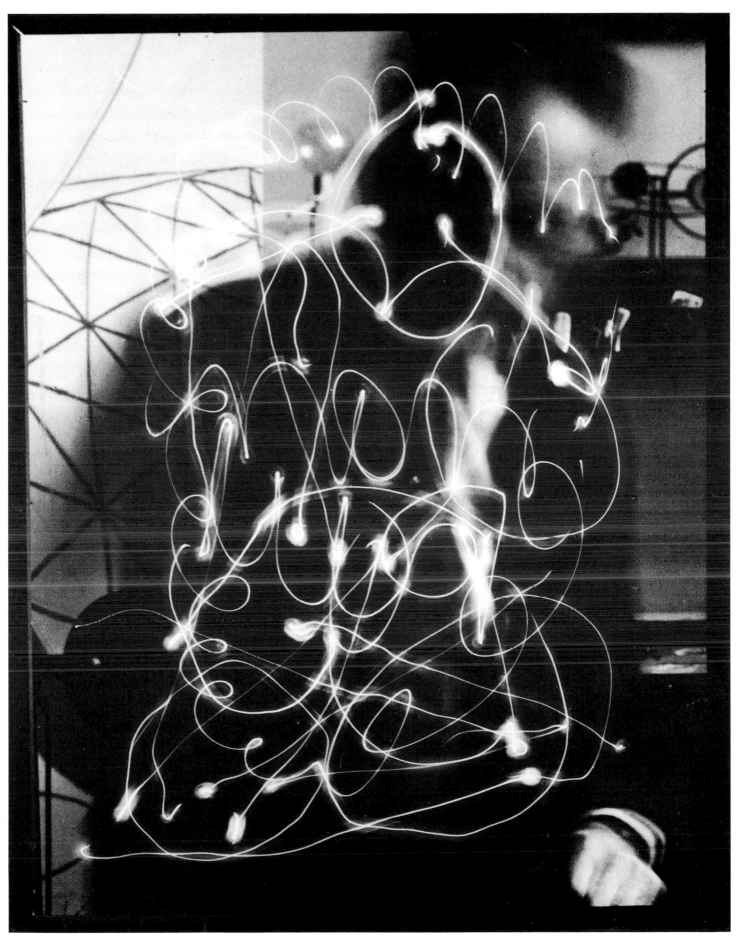

35 Space-Writing, *1936*

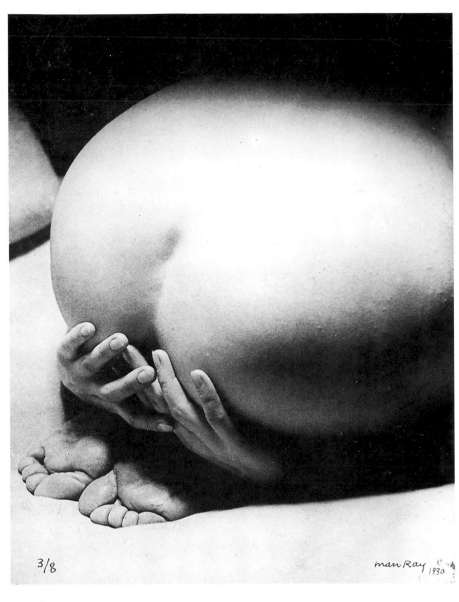

3/8 man Ray 1930

36 Prayer, *1930*

Opposite:
37 Violon d'Ingres
(Kiki de Montparnasse), *1924/1980*

*Shortly after Man Ray moved to Paris's
bohemian Montparnasse section,
he met Alice Prin, better known as Kiki.
She became his lover and favorite model.
"Her body would have inspired any
academic painter. Looking at her from
head to foot I could find no physical defect."*

Behind the Camera

"Whatever the medium, it is the man behind the work who makes it art."

Man Ray bought his first camera at the age of twenty-four, intending only to photograph his own work. Toward 1922, however, when his first exhibit in Paris proved a critical success in avant-garde circles but only scandalized the public, Man Ray was obliged to set painting aside and earn his living behind the camera.

He first photographed his friends—the poets, painters, and musicians he associated with—then their friends and partners, until his varied and impressive gallery of photographs made him celebrated. The brightest names in Paris society considered it an honor to sit for a portrait by Man Ray. But it was the female form that inspired his most poetic and unusual images, many of them relying on techniques he had himself developed and exploited masterfully.

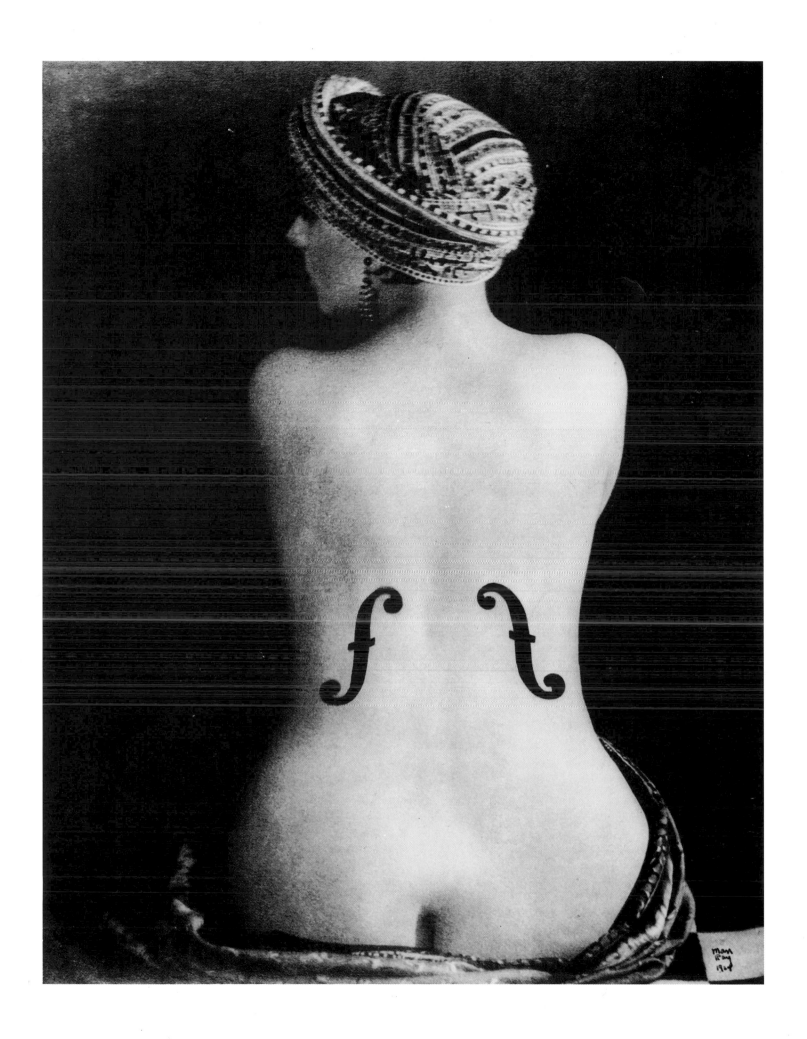

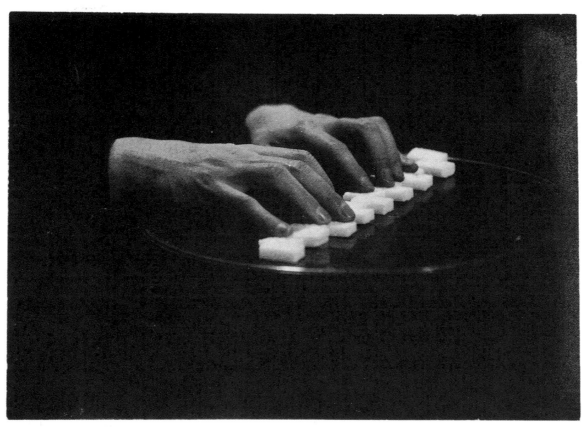

38 The Hands of Antonin Artaud, *1922*

*Man Ray's camera read well the tragic
and rebellious nature of Antonin Artaud,
who strove to bring onto the stage "the
unspeakable eruption of a world . . . at a
tangent to the real" and devoted his life
to a "Theater of Cruelty."*

 *As if by alchemy, and with the help
of judicious lighting, Man Ray transforms
the appearance of things to the point of
being unrecognizable. Beneath Artaud's
slender fingers, the lumps of sugar have
assumed the look of a keyboard.*

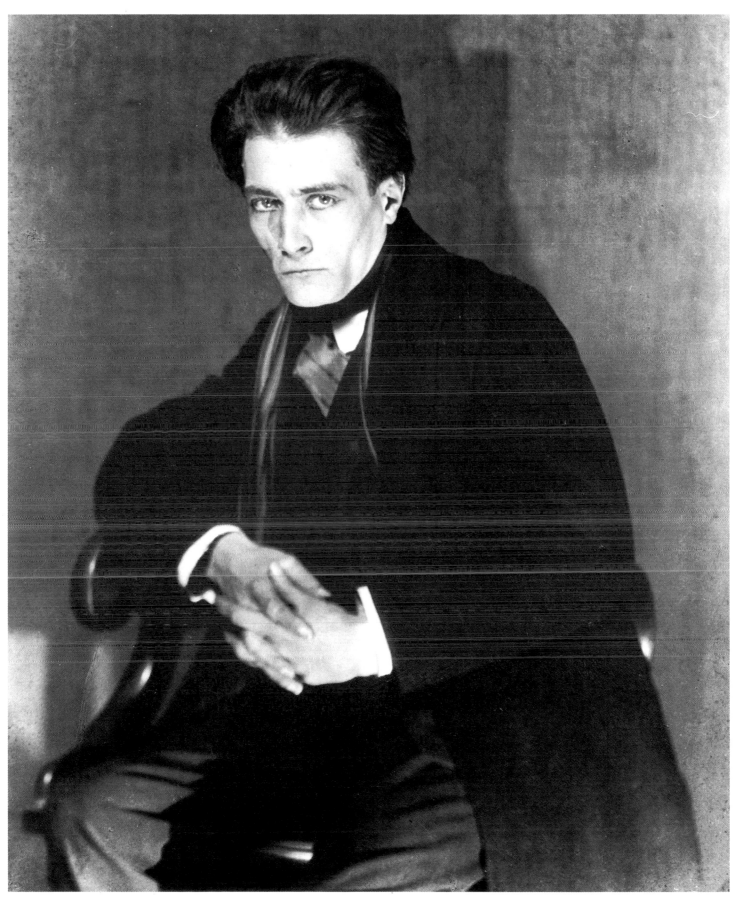

39 Antonin Artaud, *1926/1980*

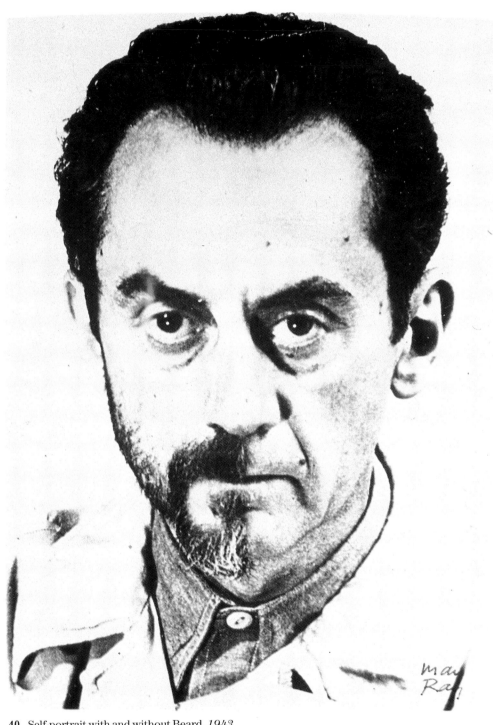

40 Self-portrait with and without Beard, *1943*

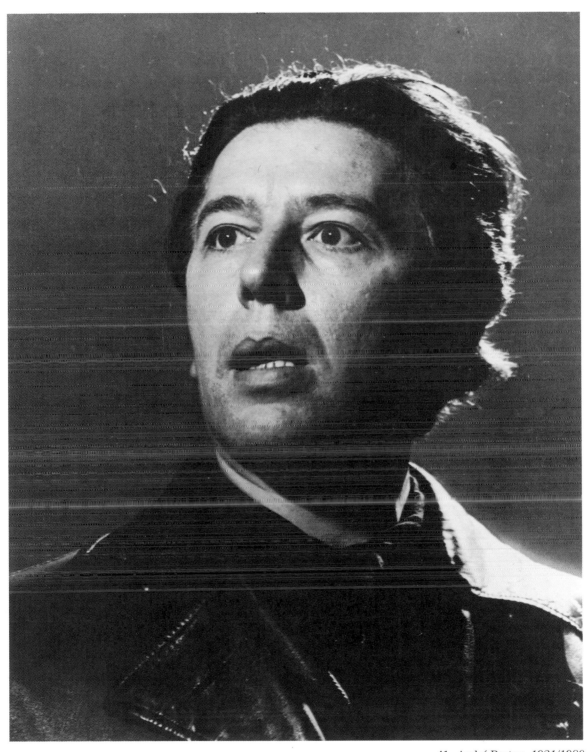

41 André Breton, *1921/1980*

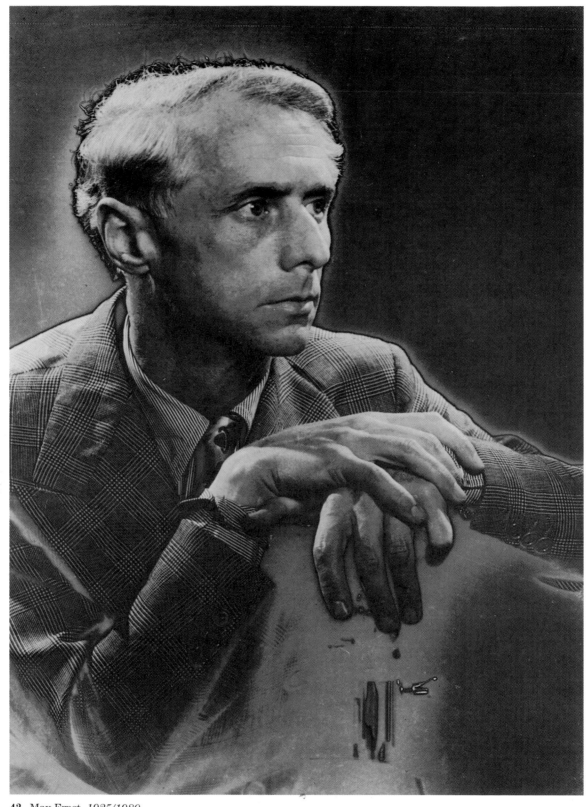

42 Max Ernst, *1935/1980*

Opposite:
43 Veiled Erotic (Meret Oppenheim), *1933*

"Convulsive beauty will be veiled erotic,"
wrote André Breton in L'amour fou. *Here,*
Man Ray freights the picture with sexual
allusion through the analogy of forms. The
woman is Meret Oppenheim, the maker of
Surrealist objects, who stands naked, her
body smeared with ink, partly hidden by
the wheel of a printer's press.

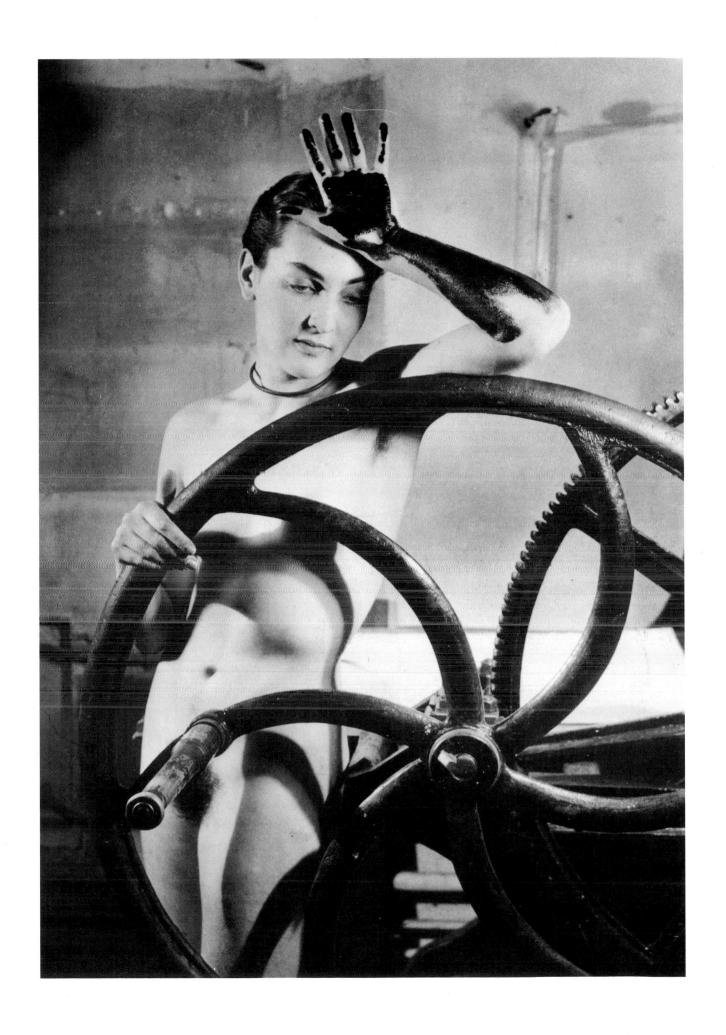

44 Dora Maar, *1936/1980*

A painter and photographer associated with the Surrealists, Dora Maar was Picasso's lover and inspired his Weeping Woman series of drawings and paintings.
In Man Ray's vision, Dora Maar becomes an incarnation of dreams and melancholy.

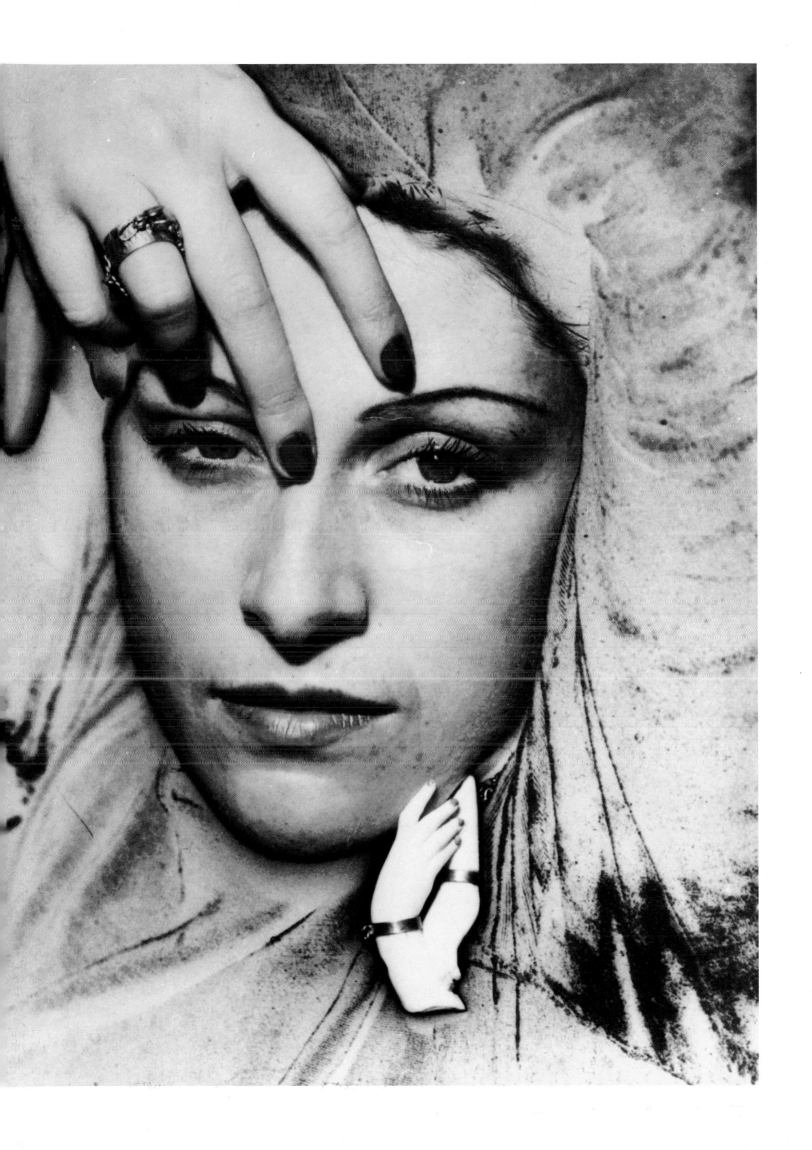

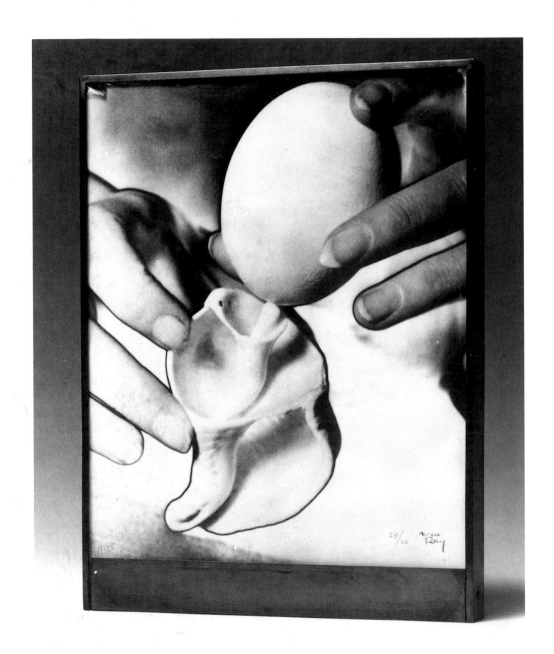

45 Egg and Shell, *1931*

Opposite:
46 Natasha, *1934*

"Nudes have always been one of my favorite subjects, in paintings as well as in photographs, and I have to admit that this is not just for artistic reasons."

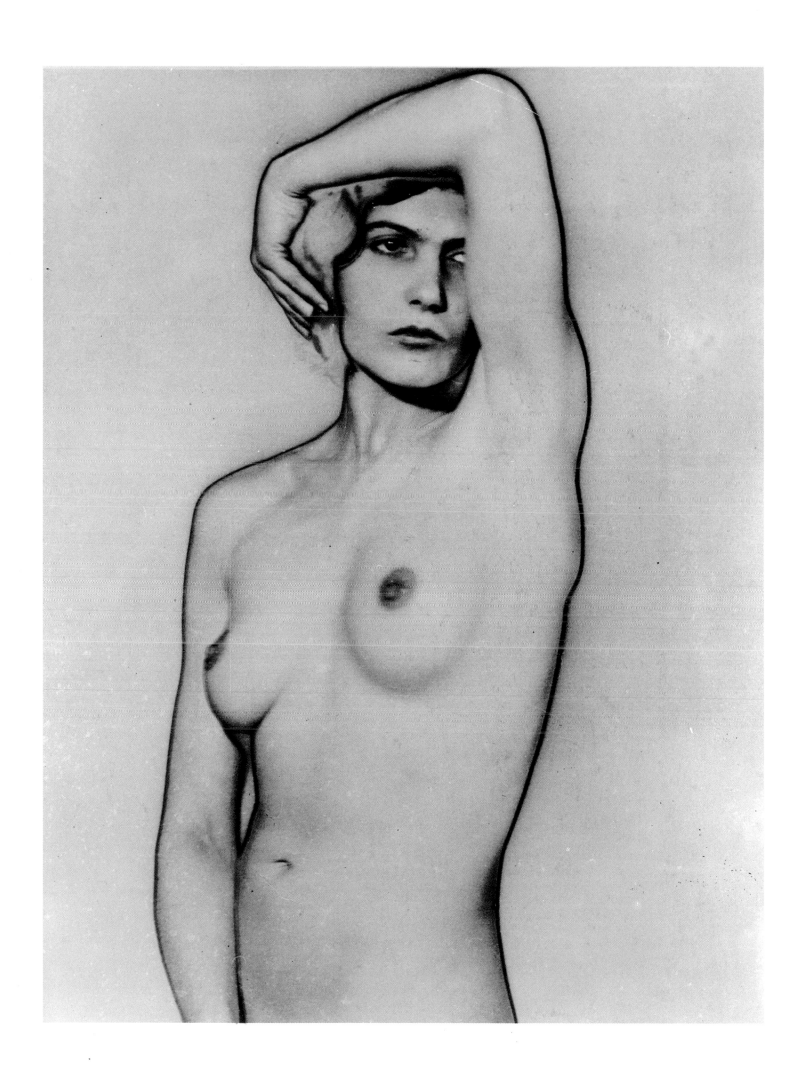

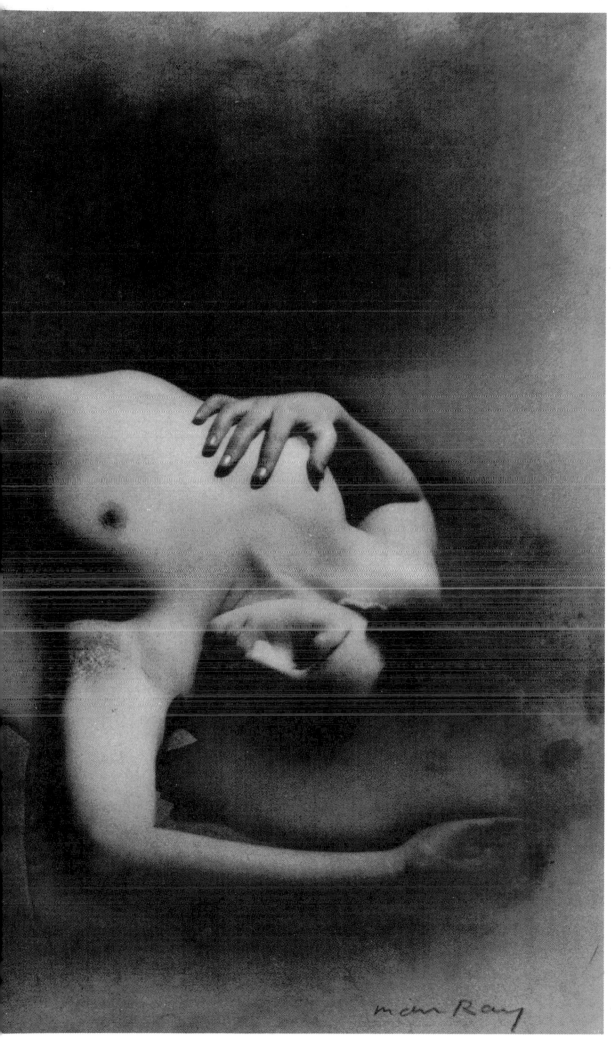

"Photographing a nude took extraordinary effort, and the more beautiful the model the harder it was to create something that did justice to her beauty."

The unusual effects Man Ray achieves with this nude are the result of solarization.

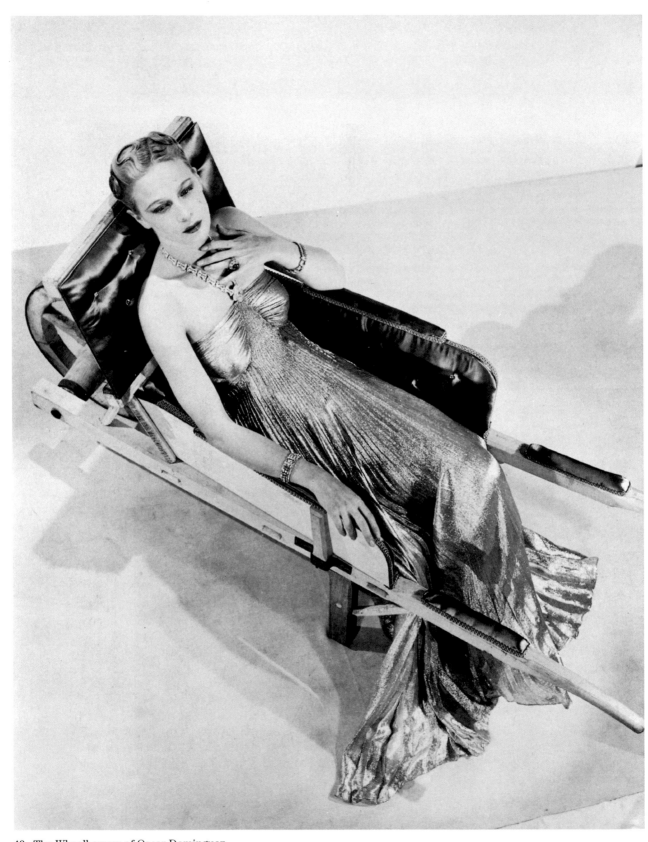

48 The Wheelbarrow of Oscar Dominguez,
Dress by Lucien Lelong, *1937*

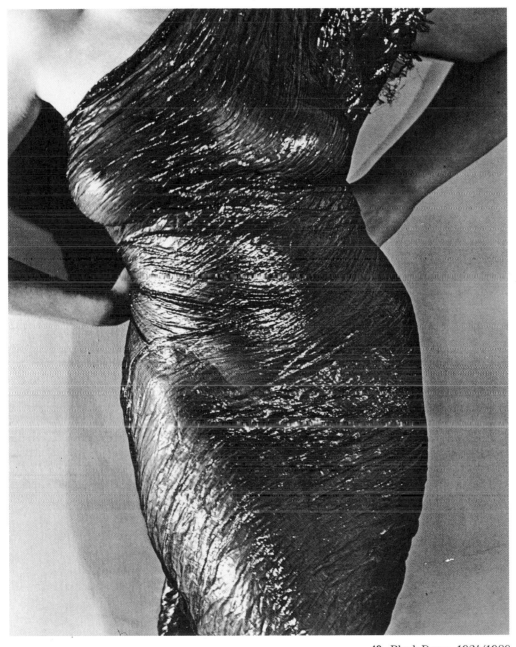

49 Black Dress, *1934/1980*

"I wanted to combine art and fashion."

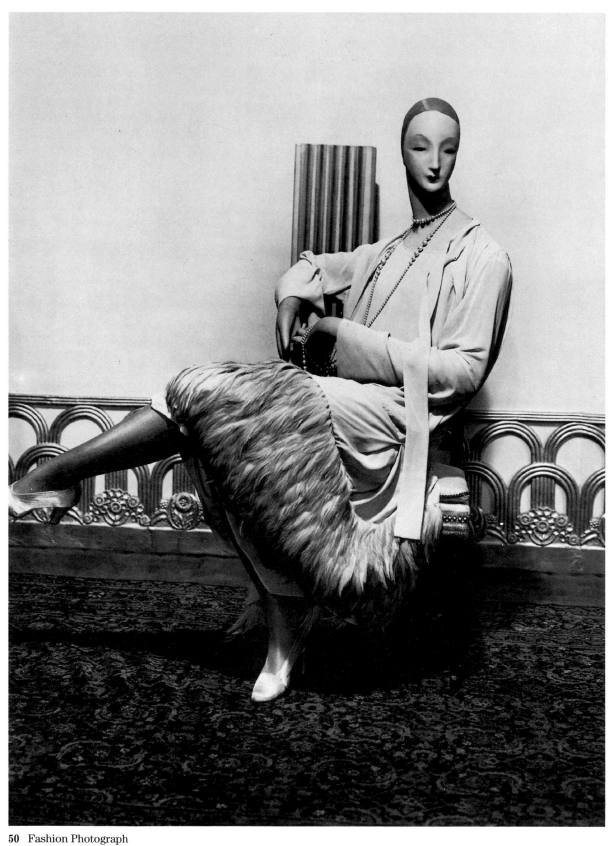

50 Fashion Photograph
(Wooden Mannequin), *1925*

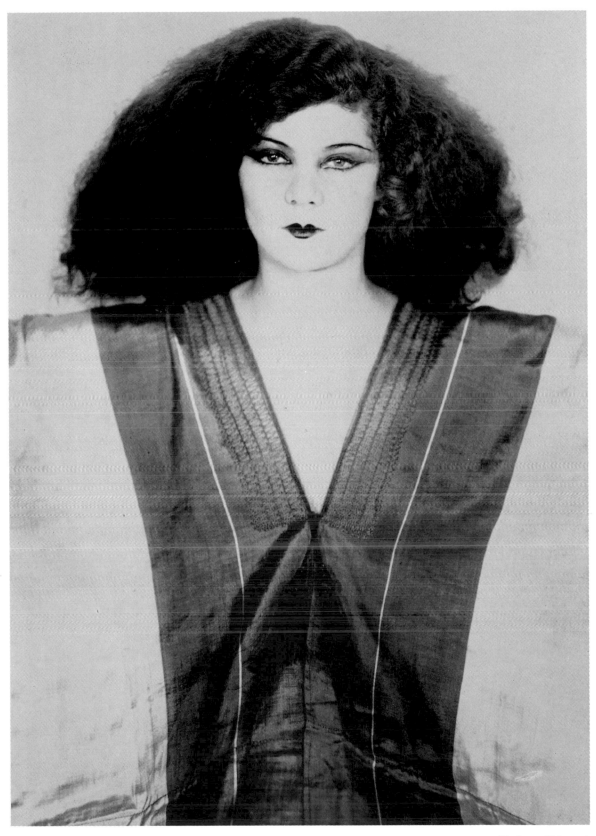

51 Long Hair, *n.d.*

52 Imaginary Portrait of D.A.F. de Sade, *1938/1970*

53 Not Understood, *1938*

"Like a Dream Remembered"

"It was inevitable that the continued contact with painters should keep smoldering in me my first passion—painting."

In the 1930s, while Man Ray's services as a photographer were more and more in demand, he produced a new series of paintings that show not only a return to his "first passion" but a transition to a new artistic vision. No longer reducing his images to two dimensions, he developed an illusionist pictorial space that was better adapted to his dreamscapes. Perspective is indicated by the tilt of the paving stones, as in *Not Understood* (plate 53) and *Rebus* of 1938; by the gradual reduction in size of the elements from foreground to background, as in *Imaginary Portrait of D.A.F. de Sade*, 1938 (plate 52); or by the inclusion of a horizon line, as in *Observatory Time—The Lovers*, 1932–34 (plate 58).

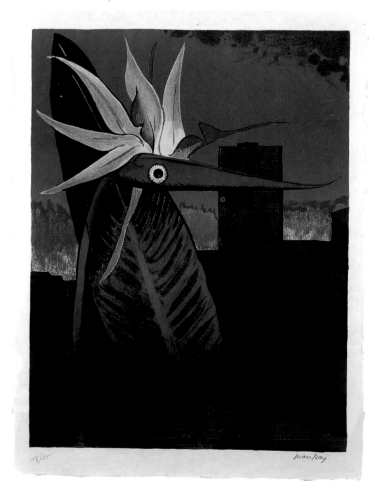

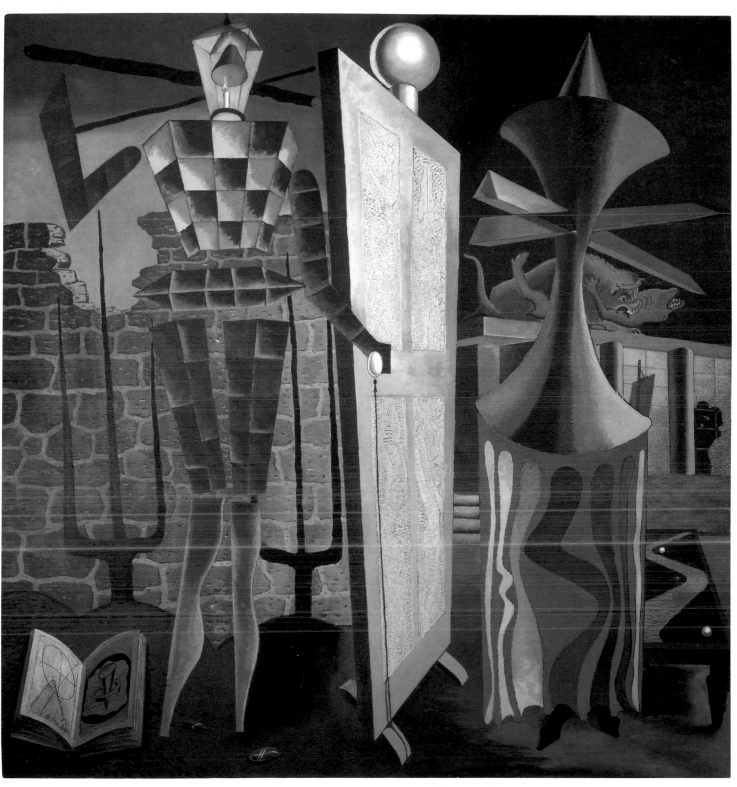

54 Le Beau Temps (Fair Weather), *1939*

*"I had almost no photographic work, so turned to painting, executing
several large canvases. One of these was a composition of several
dreams, done in brilliant colors and using all techniques, from
Impressionist to Cubist and Surrealist. Now and then I'd drive out
to my new little house in St.-Germain-en-Laye. . . . One night I heard
distant guns, and when I fell asleep again, dreamed that two
mythological animals were at each other's throats on my roof. I made
a sketch of this and incorporated it in the dream painting, which I
called: Le Beau Temps (Fair Weather)."*

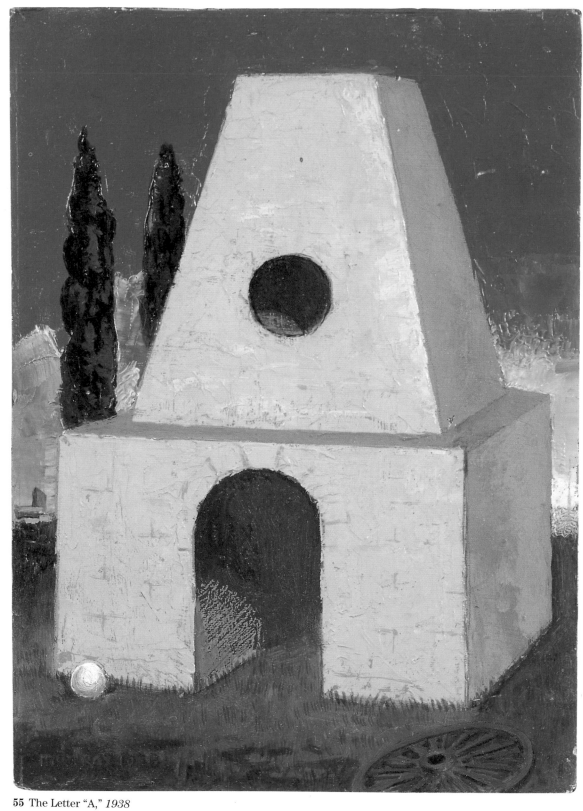

55 The Letter "A," *1938*

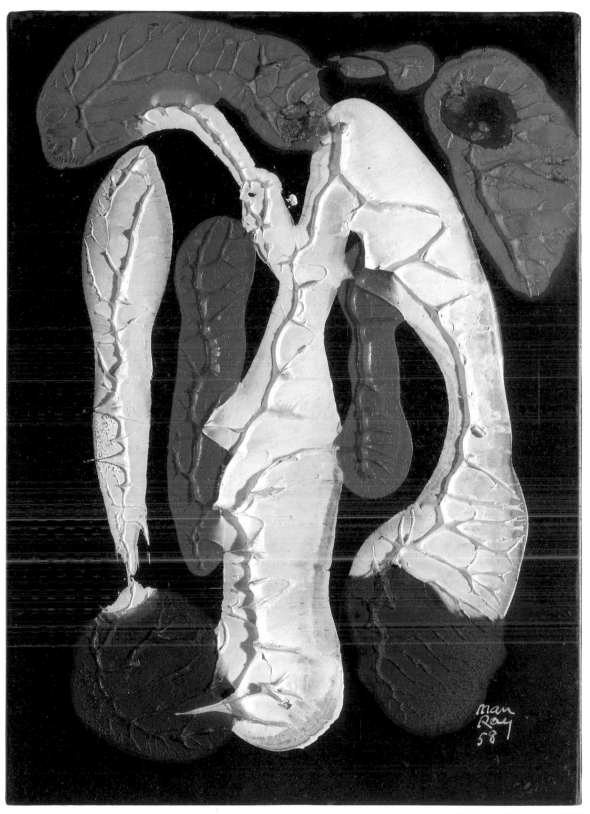

56 Natural Painting, *1958*

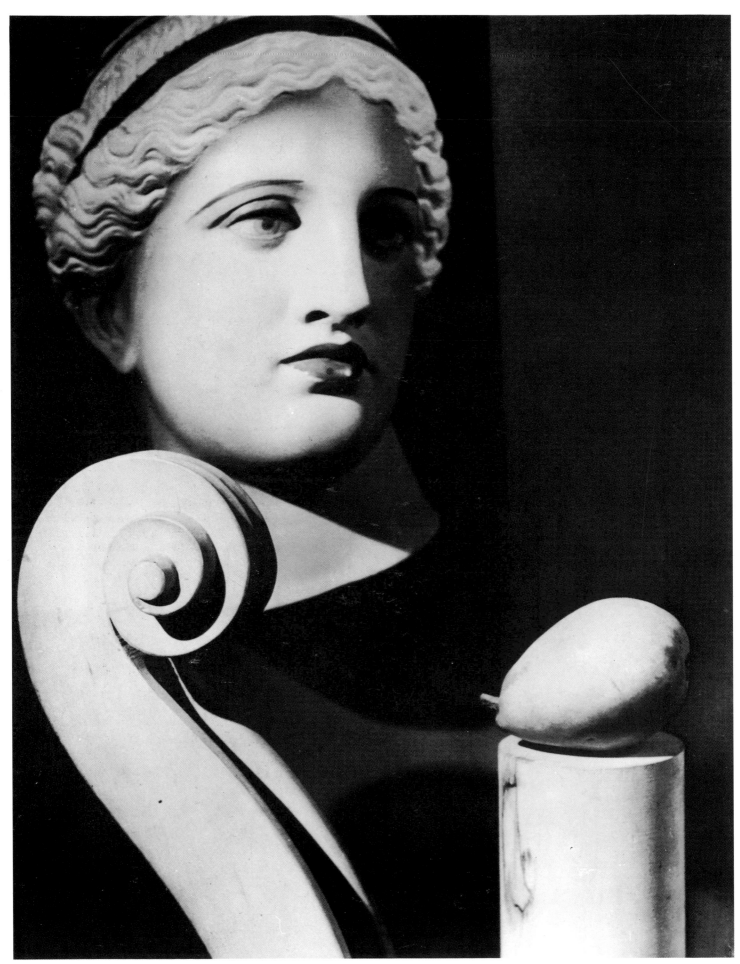

57 Surrealist Composition, *1930/1980*

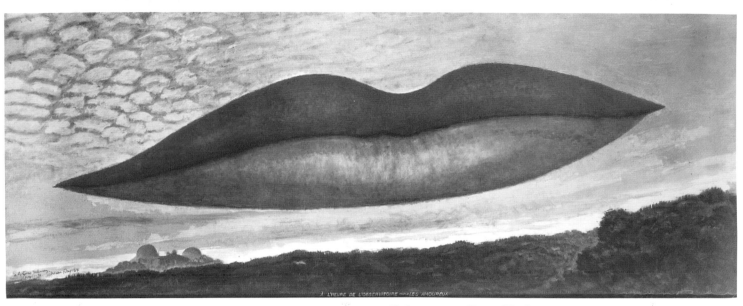

58 Observatory Time—The Lovers, *1932–34/1964*

"Some of the most effective photographs in black and white I had made were magnifications of a detail of the face and body. . . . One of these enlargements of a pair of lips haunted me like a dream remembered; I decided to paint the subject on a scale of superhuman proportions. . . .

"The red lips floated in a bluish gray sky over a twilit landscape with an observatory and its two domes like breasts dimly indicated on the horizon—an impression of my daily walks through the Luxembourg Gardens. The lips because of their scale, no doubt, suggested two closely joined bodies. Quite Freudian. I wrote the legend at the bottom of the canvas to anticipate subsequent interpretations: Observatory Time—The Lovers."

59 La Fortune (Chance), *1938*

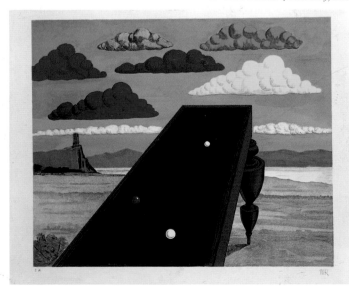

List of Plates

Note on dating: a hyphen between dates is used to indicate the period over which a work was composed; a solidus indicates when it was re-created.

1 Nude, *1912. India ink on paper, 15 × 10⅞" (38 × 27.5 cm). Private collection*

2 Self-Portrait, *1914. India ink on paper, 16¾ × 11¾" (42.5 × 30 cm). Private collection*

3 The River, *1914. Wash on paper, 11 × 8⅝" (28 × 22 cm). Private collection*

4 The Village, *1913. Oil on canvas, 20⅛ × 16⅛" (51 × 41 cm). Collection Arturo Schwarz, Milan*

5 The Lovers, *1914. Oil on canvas, 9½ × 13⅞" (24 × 35.2 cm). Collection Sylvio Perlstein, Antwerp*

6 Man Ray 1914, *1914. Oil on sketchblock (compressed paper), 6¾ × 4⅞" (17.3 × 12.3 cm). Scottish National Gallery*

7 Portrait of Alfred Stieglitz, *1913. Oil on canvas, 10⅜ × 8½" (26.5 × 21.5 cm). Yale University Museum, New Haven*

8 Promenade, *1915. Watercolor and India ink, 10⅞ × 7⅞" (27.5 × 20 cm). Private collection, Geneva*

9 The Rope Dancer Accompanies Herself with Her Shadows, *1916. Oil on canvas, re-created as a silkscreen in 1970, 22¼ × 18⅞" (56.5 × 48 cm). The Museum of Modern Art, New York*

10 Orchestra, *1916–17/1926, from the Revolving Doors series. Silkscreen, 21⅞ × 15" (55.5 × 38 cm). Private collection*

11 Mime, *1916–17/1942, from the Revolving Doors series. Collage of colored paper on white cardboard, reworked in 1942 as an oil painting on canvas, 29¾ × 19¾" (75.7 × 50.2 cm). Private collection*

12 The Meeting, *1916–17/1942, from the Revolving Doors series. Oil on canvas, 29¾ × 19¾" (75.7 × 50.2 cm). Private collection*

13 Danger/Dancer, *1920. Airbrush, re-created as a silkscreen on Plexiglas in 1971, 22½ × 13⅜" (57 × 34 cm). Private collection*

14 La Logique Assassine, *1919. Typographic design, 28⅞ × 21" (73.5 × 53.5 cm)*

15 Boxing Match, after Marcel Duchamp, *1920. Etching, 20½ × 14¾" (52 × 37.5 cm). Re-created in 1970*

16 Self-portrait, *1916. Oil and aluminum paint, with bells and push button, re-created as a silkscreen in 1970, 20¼ × 14⅝" (51.5 × 37 cm)*

17 Coat Stand, *1920. Photograph, 9⅜ × 6⅛" (23.7 × 15.6 cm)*

18 The Enigma of Isidore Ducasse, *1920/1971. Sewing machine wrapped in a blanket, 17¾ × 22⅞ × 9" (45 × 58 × 23 cm). Private collection*

19 Obstruction: Assembly Instructions, *1920/1964. Black-and-white lithograph, 17¾ × 22¼" (45 × 56.5 cm)*

20 Obstruction, *1920/1964. Wooden coat hangers. Private collection*

21 Priapus Paperweight, *1920/1972. White marble, 19⅝ × 11⅜" (50 × 29 cm). Collection Giorgio Marconi, Milan*

22 New York, *1920/1973. Metal ball bearings in stoppered test tube, 10¼ × 2¾" (26 × 7 cm). Private collection*

23 The Gift, *1921. Flatiron, with fourteen tacks, 3⅞ × 3⅞ × 7⅛" (10 × 10 × 18 cm). Private collection*

24 Lampshade, *1919/1964. Anodized aluminum, 41⅜ × 19⅝ × 19⅝" (105 × 50 × 50 cm). Private collection*

25 Object to Be Destroyed, *1923/1963. Metronome, with photograph of an eye, 8⅝ × 4⅜ × 4⅜" (22 × 11 × 11 cm). Private collection*

26 Serious Man, *1968–72. Collage on cardboard, with walnut stain and string, 19⅝ × 12¾" (50 × 32.5 cm). Collection Giorgio Marconi, Milan*

27 Close-up, *1963. Collage on paper, with needles, 15 × 11" (38 × 28 cm). Collection Giorgio Marconi, Milan*

28 Delicious Fields, *1921–22. Rayograph, 8¾ × 6¾" (22.3 × 17 cm). Collection Giorgio Marconi, Milan*

29 Delicious Fields, *1921–22. Rayograph, 8¾ × 6¾" (22.3 × 17 cm). Collection Giorgio Marconi, Milan*

30 Delicious Fields, *1921–22. Rayograph, 8¾ × 6¾" (22.3 × 17 cm). Collection Giorgio Marconi, Milan*

31 Delicious Fields, *1921. Rayograph, 8¾ × 6¾" (22.3 × 17 cm). Collection Giorgio Marconi, Milan*

32 Untitled, *1923. Rayograph, 19⅜ × 15¾" (49.3 × 40 cm). Collection Giorgio Marconi, Milan*

33 Untitled, *1945. Rayograph, 13¾ × 11" (35 × 28 cm). Collection Giorgio Marconi, Milan*

34 Untitled, *1927. Rayograph, 11¾ × 9⅞" (30 × 25 cm). Collection Giorgio Marconi, Milan*

35 Space-Writing, *1936. Photograph, 6⅛ × 4½" (15.5 × 11.5 cm). Private collection*

36 Prayer, *1930. Photograph, 9 × 6¾" (23 × 17 cm). Collection Paolo Rosselli, Milan*

37 Violon d'Ingres (Kiki de Montparnasse), *1924/1980. Photograph, 11¾ × 9½" (30 × 24 cm). Private collection, Paris*

38 The Hands of Antonin Artaud, *1922. Photograph, 3 × 4⅜" (7.6 × 11 cm). Collection Giorgio Marconi, Milan*

39 Antonin Artaud, *1926/1980. Photograph, 11¼ × 9" (28.5 × 23 cm). Collection Giorgio Marconi, Milan*

40 Self-portrait with and without Beard, *1943. Photograph, 3 × 4⅛" (7.6 × 10.5 cm). Collection Giorgio Marconi, Milan*

41 André Breton, *1921/1980. Photograph, 11¾ × 9½" (30 × 24 cm). Private collection*

42 Max Ernst, *1935/1980. Photograph, 11¾ × 9½" (30 × 24 cm). Collection Giorgio Marconi, Milan*

43 Veiled Erotic (Meret Oppenheim), *1933. Photograph, 12 × 9½" (30.5 × 24 cm). Collection Giorgio Marconi, Milan*

44 Dora Maar, *1936/1980. Photograph, 9 × 11¾" (23 × 30 cm). Private collection*

45 Egg and Shell, *1931. Solarized photograph, 11¾ × 9⅞" (30 × 25 cm)*

46 Natasha, *1934. Solarized photograph, 11¾ × 8⅞" (30 × 22.5 cm)*

47 The Primacy of Matter over Mind, *1929. Solarized photograph, 8⅝ × 11¾" (22 × 30 cm). Collection Arturo Schwarz, Milan*

48 The Wheelbarrow of Oscar Dominguez, Dress by Lucien Lelong, *1937. Photograph, 9⅞ × 7⅞" (25 × 20 cm). Private collection, Paris*

49 Black Dress, *1934/1980. Photograph, 11¾ × 9½" (30 × 24 cm)*

50 Fashion Photograph (Wooden Mannequin), *1925. Photograph, 11⅜ × 9" (29 × 23 cm). Private collection*

51 Long Hair, *n.d. Photograph, 16 × 11¾" (40.5 × 30 cm). Private collection, Paris*

52 Imaginary Portrait of D.A.F. de Sade, *1938/1970. Oil on canvas, re-created as a color lithograph, 30⅜ × 22½" (77 × 57 cm)*

53 Not Understood, *1938. Oil on canvas, re-created in 1962 as a color lithograph, 29⅞ × 22" (76 × 56 cm). Collection Giorgio Marconi, Milan*

54 Le Beau Temps (Fair Weather), *1939. Oil on canvas, 82⅝ × 78¾" (210 × 200 cm). Estate of Juliet Man Ray and the Man Ray Trust, Paris*

55 The Letter "A," *1938. Oil on panel, 8⅝ × 6¼" (22 × 16 cm). Collection Giorgio Marconi, Milan*

56 Natural Painting, *1958. Mixed media on metal, 6⅞ × 4¾" (17.5 × 12 cm). Private collection*

57 Surrealist Composition, *1930/1980. Photograph, 11¾ × 9½" (30 × 24 cm). Collection Giorgio Marconi, Milan*

58 Observatory Time—The Lovers, *1932–34/1964. Oil on canvas, re-created as a color photograph, 19⅝ × 48⅞" (50 × 124 cm). Collection Arturo Schwarz, Milan*

59 La Fortune (Chance), *1938. Color lithograph, 21⅝ × 29½" (55 × 75 cm). Collection Giorgio Marconi, Milan*

Selected Bibliography

Alexandrian, Sarane. Man Ray. *Paris: Fillipachi, 1973.*

Baldwin, Neil. Man Ray: American Artist. *New York: Clarkson N. Potter, 1988.*

Jaguer, Edouard. Les Mystères de la chambre noire. Paris: Flammarion, 1982.

Jouffroy, Alain. Introduction au génie de Man Ray. *Exh. cat. Paris: Musée National d'Art Moderne, 1972.*

Kiki. Souvenirs. *Paris: Black Manikin Press, 1929.*

Man Ray 1890–1976. *Exh. cat. New York: Harry N. Abrams, Inc., 1995.*

Man Ray Photographs. *New York: Thames and Hudson, 1982.*

Man Ray. Self Portrait. *Boston: Atlantic–Little, Brown, 1963. Reprint, Boston: New York Graphic Society, 1988.*

Palazzoli, Daniela. Man Ray, la construzione dei sensi. *Milan: Fabbri Editori,1995.*

Penrose, Roland. Man Ray. *Boston: New York Graphic Society, 1975.*

Rubin, William S. Dada, Surrealism, and Their Heritage. *Exh. cat. New York: Museum of Modern Art, 1968. Reprint, 1977.*

Schwarz, Arturo. Man Ray: The Rigor of Imagination. *New York: Rizzoli, 1977.*

Series Coordinator, English-language edition: Ellen Rosefsky Cohen
Editor, English-language edition: Nola Butler
Designer, English-language edition: Judith Michael

Library of Congress Catalog Card Number: 97–77351
ISBN 0–8109–4672–6

Printed and bound in Spain by Filabo, S.A.

Dep. Leg.: B. 44.993–1997